SANCTUARY. STEVE McCURRY
THE TEMPLES OF ANGKOR
INTRODUCTION BY JOHN GUY

THE TEMPLES OF ANGKOR JOHN GUY

Angkor is a site of astounding scale and majesty that stands as one of the greatest achievements of the medieval world, in Asia or Europe. The name means royal city (Khmer *nokor*), and derives from the Sanskrit *nagara*, city or capital. The site is a complex fusion of buildings and environment, the product of the bringing together of religious architecture and an engineered landscape. But it is not without a human dimension: almost every temple bears an inscription which securely attaches a historical personality to the building. Many of those inscriptions record a temple's dedication to a patron's parents or ancestors. The temples were built as abodes for the gods, and some may have ultimately served as funerary monuments for their builders. All were animated by the presence and activity of people – kings, priests, and the 'slaves of the gods', the *devadasi* (the human form of the heavenly *apsaras*). For a thousand years Angkor has attracted traders, priests and pilgrims, as well as raiders and plunderers. Steve McCurry has understood the importance of this human presence, this life within the architectural landscape, and it is perhaps this that gives his photographs their special quality.

It was to travellers of the later nineteenth century that Cambodia first became synonymous with Angkor. Imaginations were fuelled by the romantic descriptions and illustrations of the ancient temples which began to appear in France from the 1860s. Henri Mouhot's description of his first sighting of Angkor in 1859 reflects the mood of the times:

RUINS OF SUCH GRANDEUR, REMAINS OF STRUCTURES WHICH MUST HAVE BEEN RAISED AT SUCH AN IMMENSE COST OF LABOUR, THAT, AT FIRST SIGHT, ONE IS FILLED WITH PROFOUND ADMIRATION ... ONE OF THESE TEMPLES [ANGKOR WAT] ... MIGHT TAKE AN HONOURABLE PLACE BESIDE OUR MOST BEAUTIFUL BUILDINGS. IT IS GRANDER THAN ANYTHING LEFT TO US BY GREECE OR ROME.

The Parisian Universal Exposition of 1867 exhibited the wonders of Angkor in plaster casts and drawings, and the 1878 Exposition displayed the first original Angkorian sculptures and architectural elements to be seen in the West, removed by French archaeologists in the preceding decade. The antiquities of Angkor featured prominently in later French colonial exhibitions, stimulating successive generations of travellers and adventurers.

In 1901 the French government established the Ecole Française d'Extrême-Orient, primarily to undertake the study of the ancient monuments of French Indochine. Angkor immediately became the main focus of this research. A succession of eminent scholars – archaeologists, epigraphists and art historians – devoted their energies over the next seventy years to these monuments and the fragmentary history embodied in the associated inscriptions. Equally significantly, they undertook the clearing of the jungle and the systematic restoration of the major temples. This work was not without its critics who lamented the loss of the image of the romantic ruin, enveloped in the serpentine roots of a banyan tree. As a concession to this view, the temple of Ta Prohm was only partially cleared, so that today the visitor can still indulge in a romantic vision of the past.

Angkor remained a familiar name, mentioned alongside Egypt's Valley of the Kings, China's Terracotta Army and Java's Borodudor, as one of the wonders of the ancient world. Yet the name Angkor has lapsed from popular consciousness in recent times, due mainly to the inaccessibility of Cambodia during the Khmer Rouge years, which started with their 'Year Zero' (1975) and lasted until the Vietnamese army invaded, forcing Pol Pot's murderous regime into rural retreat. Since the restoration of civil order in Cambodia in the late 1980s visitors have again returned, to rediscover the extraordinary man-made landscape of temples and great lakes which are most associated with the name Angkor.

Angkor is made up of some hundreds of temples, built over a four hundred-year period of continuous building activity between the beginning of the ninth and the end of the thirteenth centuries. The precise number of temples will never be known, as many were no doubt consumed by new building projects, the shaped stones and bricks of earlier temples being recycled in later structures. Others, such as palaces and monastic residences, would have been of timber construction and hardly a trace of these now remains. Only laterite footings for wooden pillars, and the remnants of fired ceramic roof tiles hint at the grandeur of these lost buildings. We have a good visual record of their appearance from contemporary relief sculptures, most vividly those seen on the outer enclosure galleries of the Bayon, carved in the first decades of the thirteenth century.

The scale and historical complexity of the site is difficult to grasp. A map of the Angkor region shows a site plan that is reluctant to reveal the logic of the relationship of its parts (see p.119). The key to understanding it is firstly time; these structures were built over an extended period of around four hundred years, so that the site embodies many generations of building activity, with reservoirs and city walls often intersecting earlier structures with little regard for what had come before. The site therefore evolved in response to shifting geomorphic and political constraints.

The second and related key to understanding the disposition of the temples in the landscape is their relationship to the waterways and lakes. The control and management of the river systems and of seasonal rains was a critical factor, particularly the capture of flood waters resulting from each monsoon through a succession of systems of man-made canals and storage reservoir lakes (*barays*). This generated the wealth and surplus labour that the kings of Angkor required to undertake their ambitious building programmes, for it was with this control of water that a second cropping of rice was possible. The importance of this management of water is reflected in the number of times the Khmer rulers relocated their capital: in each case the silting up of the irrigation system seems to have been a factor. In all cases temples were juxtaposed to these man-made water systems to allow for the performance of ceremonies which would guarantee an abundance of water and crop yields. Significantly, every major *baray* had a temple situated in it on a man-made island, underscoring

the importance of the association of temple to water. The consistency of this practice throughout the Angkorian period is witnessed by the temple of Lolei (893), sited in the first major *baray* built at Rolous, the location of the earliest Khmer capital in the Angkorian period, the East Mebon (953) in the East Baray, and the West Mebon (before 1066) in the West Baray, and finally Neak Pean (late twelfth century), constructed at the centre of the *baray* which served the temple of Preah Khan.

The origins of Angkor are older than these sites suggest. The need to establish capital cities, with all the requirements of urbanization and temple building that this implies, was in evidence in Cambodia several centuries earlier. Khmer-speaking rulers had previously established capitals in the sixth and seventh centuries north and east of Angkor, at Wat Phu, Sambor Prei Kuk, and to the south at Angkor Baray and Phnom Da. Even earlier kingdoms almost certainly existed, but all that remains is the memory of the names given them by the contemporary Chinese chronicles. The most significant kingdom was known to the Chinese as 'Funan'. It was most probably located in coastal Cambodia and extended around the Gulf of Thailand, with its prosperity built on the early international trade which circulated around the shorelines of maritime Asia, linking the worlds of China and India. A Funanese entrepôt, Oc Eo, has been identified in the Mekong river delta (west of modern Ho Chi Minh City) which included in its trading inventories semi-precious Indian intaglio seals and Roman coins, indicating the extent of the trading networks in the early centuries AD. Chinese references

to Funan disappear from the record in the sixth century, at precisely the time that another name appears, 'Chenla'. It is assumed that this state, located in the interior, conquered or otherwise absorbed Funan, uniting the Khmer-speaking peoples into a political entity which approximates the territorial limits of modern Cambodia. The Khmer ancestral home may have been in the area of Wat Phu, upstream on the Mekong in modern Laos, where the remains of a sixth-century walled city are now being investigated. But there were other centres of Khmer authority downstream of Wat Phu which could also have been contenders, most notably the walled city of Sambor Prei Kuk, perhaps the Bhavapura of a late-sixth century inscription. A degree of political consolidation took place in the second half of the sixth century, and the first Khmer-language inscription (as opposed to Sanskrit, which was universally used in the earliest period), dated to 612 AD, was recovered at Angkor Borei, a southern Cambodian site with a long history of settlement. It was, for example, connected to Oc Eo by a canal network (which can still be traced), ensuring international linkages from the third–fourth century AD. It is also from this time that the first indigenous record of a named local ruler survives. He has a Sanskritized Indian name, Bhavavarman, and the inscription tells us that he ruled from his city of Bhavapura ('City of Bhava'), so beginning a long Khmer tradition of linking the names of rulers, their capital city and their presiding deities.

The religious history of Angkor is largely revealed through its temples. The affiliations of each temple and

of its patron are made explicit in the architectural form and its associated sculptural imagery. What is clearly manifest is the predominance of imported Indian faiths, notably Hinduism and to a much less significant extent, Buddhism. However, the overall spatial organization and configuration of Angkor has little to do with any 'grand cosmological vision', though component elements of Angkor, such as the walled royal city of Angkor Thom, do embody ideas shaped by theological and cosmological schemas. All the temples of Angkor however do embody a symbolic dimension, in that they are conceived as heavenly abodes for the gods on earth.

Far less clear is the role that indigenous beliefs played. These appear to have been associated with nature cults (animism) and a form of ancestor worship which placated ancestors to ensure that they extended spiritual protection to the living. This practice is recognized today in Cambodia as *nak pa*, ancestral spirit worship. Its role in Angkorian belief systems and ritual is unclear, but may well underlie the more enigmatic aspects of the many temple dedicatory inscriptions which do not seem to be fully explained in terms of conventional Hinduism alone.

The vast majority of temples are Hindu, with shrines dedicated to Siva and Vishnu. Siva worship prevailed as the preferred state cult, a fact witnessed by both inscriptions referring to Siva by his myriad names, and by the wide distribution of *linga* shrines in the kingdom. The worship of Siva in his *linga* form, generally characterized as representing the supreme Hindu deity through the emblem of an erect phallus, was the principal form of Brahmanical worship. Siva-*linga* shrines and their associated inscriptions make it clear that Saivism was established as a royal cult by the late sixth century, and in all probability somewhat earlier. In this context it is worthwhile to keep in mind that developed Indian orthodox Saivite practices of this kind would not have been all that old when they were 'exported' to Cambodia. Much of what is today seen as 'timeless practice' in Indian Hinduism was in fact only being standardized in the centuries immediately prior to its introduction into mainland Southeast Asia.

Buddhism, principally Mahayanist, was widely followed in early mainland and peninsular Southeast Asia. Buddhist shrines, temples and monastic establishments were built at various intervals during the Angkorian period, most prolifically during the reign of Jayavarman VII. At different points in the history of Angkor, a number of temples built for one faith were subsequently appropriated by another. The most spectacular instance of religious reappropriation is Angkor Wat itself, a temple dedicated by its builder Suryavarman II to his presiding deity, Lord Vishnu. This was later converted to the use of the Buddhist faithful of the region. A number of seventeenth-century travel accounts indicate that a sizable community of Theravada Buddhist monks resided there in the post-Angkorian period, when the site was known as 'Jetavana' after a major Buddhist pilgrim centre in India. Indeed, one foreign visitor, a Japanese, in all probability resident at Ayutthaya (the capital of Siam), undertook a pilgrimage to Angkor and prepared the earliest extant drawings of Angkor Wat (*c.*1623–36).

Throughout most of the Angkorian period, the supreme presiding deity was Siva. Dedicatory inscriptions make clear that the Khmer ruling households paid homage to Siva as their protective deity, invoked to secure the personal welfare of the ruler and the territorial interests of the state. Inscriptions recording the establishment of *ashramas* (retreats) for ascetics show that followers of Brahma, Vishnu and the Buddha also received support, alongside the dominant sect devoted to Siva.

Phnom Kulen, the mountain plateau northeast of Angkor, was chosen by King Jayavarman II as his capital of Mount Mahendra and in 802 he had himself re-invested as supreme ruler, governing under the spiritual protection of Lord Siva. According to the eleventh-century inscription which recounts Jayavarman II's reign, this ritual, perhaps involving a golden image of Siva, was instigated by the hereditary Brahman priests who had secured the confidence of the ruler through their performance of exotic ritual and acts of magic. The Khmer name of this installation ritual ceremony or *puja* translated into Sanskrit as *Devaraja*, 'God-king', a term which has been mistakenly associated in much past writings on Angkorian religion with the person of the ruler himself, rather than with the deity under whose protection he ruled.

Temples, shrines and palaces were built at Mount Mahendra, but the location on Phnom Kulen, with limited access to water, could not sustain an expanding city. Around Kulen the Khmer preoccupation with the life-generating powers of water was given expression in the sculpting of Siva-*linga* and images of Vishnu and Laksmi into the living rock of stream-beds, as seen at nearby Kbal Spean and on the Kulen plateau itself. It was the intention that these reliefs would be washed by the seasonal rains, so harnessing the elements of nature for the performance of the ritual lustrations necessary to honour Siva and Vishnu. The river-bed reliefs were most probably carved by Hindu ascetics, perhaps members of one of the many *ashrama* or monastic retreats known to have existed throughout the kingdom, sustained by royal support.

Having exhausted the potential of Kulen, Jayavarman II moved his capital in 802 or soon after down to the Angkorian plain at Rolous, and named it Hariharalaya. His successor Indravaman I created the first major water reservoir, Indratataka, and built the Bakong, dedicated to Siva in 881, as his cult temple. This was the first step pyramid of the Angkorian period, and was conceived on a monumental scale (approaching that of Borobudor in central Java, which it post-dates by fifty or sixty years). The previous year Indravarman had completed the temple of Preak Ko (880), a cluster of six brick towers which he built to honour the spirits of former kings. This temple probably served as the royal family chapel, sited as it is within the remains of a large enclosure, possibly demarcating the site of Indravarman's palace.

The Bakong sets the agenda for the state temple in the Angkorian period. Here was a man-made mountain with stepped ascending levels on a square plan, within

a rectangular enclosure accommodating free-standing shrine towers and broken at the axial points by *gopura*-type gateways. A Saivite shrine, it had a *linga* as its principal cult image. This was the most important temple of its day, serving as Indravarman I's state temple where all the propitious ceremonies necessary for the welfare and prosperity of the state were performed. It also marks an important transition in the choice of building materials: up to this point fired brick with stucco surface adornment was the chosen material for temple building, as seen at nearby Preah Ko, and as exemplified at much earlier sites, most notably at Sambor Prei Kuk and at Phnom Kulen. The Bakong was built of iron-rich red laterite blocks, shaped and then assembled without the use of mortar. It was faced with the buff sandstone characteristic of the area. Quarries from which sandstone was supplied have been located, and it may be assumed that such materials were transported via the waterways, on bamboo pontoons. In the 1870s when Louis Delaporte acquired the monumental sculptures and architectural sections that are now the prize exhibits of the Musée Guimet in Paris, he used this method of transportation.

The Bakong, and the succession of monumental step-pyramid structures that followed over the next four centuries, would have required the services of highly trained architects, engineers and stonemasons, and an army of labourers. The works programme would have been seasonal, as the firing of bricks and quarrying of stone would have been difficult in the wet season, as would the securing of footings and core material.

The man-hours required for the water engineering and temple building programmes (disregarding for a moment the extensive timber and tile structures which would have been far more numerous) was vast. For this workforce the Khmer state almost certainly depended heavily on the 'slave' labour secured through success at war. The principal trophy of war in early Southeast Asia was not territory, as in modern warfare, but people – a commodity without which a state could not continue to grow. Skilled artisans were particularly prized, and their capture often warranted special mention in contemporary inscriptions.

Nonetheless, it is readily apparent that many of the temples were built with undue haste, presumably by patrons who sensed that their time was limited. Although there is evidence that a number of the earlier Angkorian temples were constructed with the support of more than one ruler, in the later period it was common practice for a temple to be abandoned when its patron died. Many show signs of speedy construction, and some are clearly unfinished.

Yasovarman I inherited the Bakong along with the emerging Khmer state. He built Lolei temple to honour his parents, and then, in a dramatic move that was to transform the future shape of the Angkorian capital, relocated from Rolous to Angkor, and quickly set about building a new state temple on the natural hill of Phnon Bakheng, which was dedicated to Siva in 907. Following established custom, he named his new capital after himself (Yasodharapura), with the new state temple

located symbolically at the central axis, underscoring its role as a source of protective spiritual power. Traces of Yasadharapura's earthwork wall and moat indicate a vast city by medieval standards measuring some four kilometers square, larger even than the walled city of Angkor Thom, which overlapped it in the twelfth century.

The reign of a usurper from Sambor Prei Kuk, who took the name Rajendravarman (II) and secured power in 944, is marked by another monumental state temple, Pre Rup (961). However, this reign is remembered more vividly for an altogether more modestly scaled achievement, Banteay Srei (967). Built as a private chapel by Yajnavaraha, a nobleman and chief counsellor to the king and his successor, Banteay Srei is a remarkable building. It is the most important temple built by a non-royal patron (albeit someone very close to the king) and, significantly, it is almost domestic in scale, presumably so as not to be seen as competing in importance with the works of his king. Yet in its workmanship and sophistication of decoration, Banteay Srei surpasses almost every royal building of the time. Perhaps only the sandstone lintels on the towers of the East Mebon (c.950) are a match for its delicacy of carving and inspired interpretations of Hindu mythology. One strongly senses the guiding hand of the patron in the design and realization of this masterpiece of Khmer temple architecture.

Banteay Srei was not the first temple to be built by a non-royal: the beautifully sited brick towers of Prasat Kravan (921) were built by several officials of high rank, and reveal the authority and independent wealth held by members of the Khmer elite. The shrines are dedicated to Vishnu, and two of the sanctuaries contain the finest examples of carved brick relief decoration of the Angkorian period. The flanking walls of the central sanctuary have spectacular brick reliefs of the god Vishnu shown encircling the earth in three strides, a well-known subject in Vasinavite mythology, here rendered as if Vishnu has assumed a warrior's battle posture. Opposite, Vishnu is represented seated astride his vehicle the mythical bird Garuda. A large sandstone pedestal base with rectangular socket indicates the large scale of the freestanding image of Vishnu which must have originally occupied this small sanctuary, positioned directly in front of a standing Vishnu relief on the back wall. The scale of this lost sculpture alerts us to another curious practice: that the major cult images in some temples must have been installed *before* the enveloping shrine was built, as they could not have otherwise been positioned in such confined spaces. Perhaps the roughed-out image was installed, and finished *in situ*. The consecration ceremony, which is the date consistently given in all temple inscriptions, could only be performed after the image was finished. The brick reliefs in the sanctuary interiors would undoubtedly have been rendered with a stucco ground and their surfaces finely painted, as the traces of polychrome surviving here and in other monuments indicate.

Not only was stucco and polychrome widely used in the decoration of Khmer temples. We are told by the late

thirteenth-century Chinese observer of Angkor life, Zhou Daquan, that the towers of the state temples were embellished with gold and bronze:

AT THE CENTRE OF THE KINGDOM RISES A GOLDEN TOWER [BAYON TEMPLE] ... ON THE EASTERN SIDE IS A GOLDEN BRIDGE GUARDED BY TWO LIONS OF GOLD, WITH EIGHT GOLDEN BUDDHAS SPACED ALONG THE STONE CHAMBERS. NORTH OF GOLDEN TOWER [BAYON], AT A DISTANCE OF ABOUT TWO HUNDRED YARDS, RISES THE TOWER OF BRONZE [BAPUON TEMPLE], HIGHER THAN THE GOLDEN TOWER: A TRULY ASTONISHING SPECTACLE ... A QUARTER OF A MILE FURTHER NORTH IS THE RESIDENCE OF THE KING. RISING ABOVE HIS PRIVATE APARTMENTS IS ANOTHER TOWER OF GOLD [PHIMEANAKAS]. THESE ARE THE MONUMENTS WHICH HAVE CAUSED MERCHANTS FROM OVERSEAS TO SPEAK SO OFTEN OF 'CAMBODIA THE RICH AND NOBLE'.

This contemporary description provides the only objective account we have of life in thirteenth-century Angkor and of its more spectacular sights. Largely ignorant of Hinduism, Zhou Daquan was only able to describe the religious imagery he saw in terms of his own faith, Buddhism. He refers to a number of large-scale gilt bronze sculptures, the most spectacular of which was a 'recumbent bronze Buddha, from whose navel flows a steady stream of water' in the 'Eastern Lake'. A monumental bronze, of a reclining Vishnu on the serpent Ananta, was discovered in the ruins of the island temple of the West Mebon, in the West Baray, in 1936. It is without doubt the one described by Zhou Daquan (mistakenly) as being in the East Baray. Originally over six metres in length, it is the remains of the largest known bronze sculpture in all of Southeast Asia.

The model of the temple-mountain instigated at the outset of the Angkorian period reached its ultimate expression in the first half of the twelfth century, when Suryavarman II undertook the construction of his personal temple, Angkor Wat ('city-temple'). The temple complex is orientated to the west, the direction associated with Vishnu, to whom the temple is dedicated. Construction took some twenty-seven years, with the cult image (very probably the Vishnu still in worship near the west gate in the enclosure wall passage) being consecrated in 1150. It is the biggest of all Khmer temples, and the most elaborate yet harmonious expression of the Hindu cosmology of Mount Meru, the cosmic centre of the universe surrounded by the mythical oceans. The subsidiary towers represent the abodes of the lesser gods and the central pinnacle, Mount Meru itself, rises some 65 metres above ground level. The vast area encompassed by the outer enclosure wall and moat very probably accommodated the king's palace and government.

The three-dimensional cosmology of the temple is at once arresting. The devotee, pilgrim and visitor cannot fail to grasp the way in which the architect has given form to this Hindu conception of the universe. At the heart of the temple, elevated high on its series of sharply raked platforms, is Mount Meru, which is linked at its base by four axial passages to an outer square gallery, the corners of which are capped by four secondary towers representing the lower mountains which encircle Mount Meru. A dramatic descent to the base platform reveals expanses of wall surface decorated with reliefs

of celestial dancers (*apsaras*), reminding the devotee that he is still in the heavenly palace of the gods. The passage of the outer (third) enclosure contains the most stunning narrative relief sculptures in all of Angkor – some 600 metres of relief panels, two metres in height, with some scenes in double-register, and others filling the full height with a single scene. They principally illustrate themes drawn from the two great Hindu epics, the *Mahabharata* and the *Ramayana*, with a further series of scenes of Buddhist heavens and hells. For the first time in Khmer temple art, a substantial passage of the reliefs, extending 94 metres, depicts scenes from the life of the temple's patron Suryavarman II, in the form of a royal audience and military victory parade.

This dimension to Khmer art, in which the actual ruler is depicted, personalized the state temple in a way that had not been attempted before. It found its ultimate expression in the last great outburst of public building activity at Angkor, initiated by Jayavarman VII (1181–1219). Jayavarman and his principal queen Jayarajadevi broke with the tradition of entrenched Hinduism of their predecessors, and became fervent Mahayana Buddhists. The predominant icon of Jayavarman's reign is the face of the bodhisattva Lokesvara, seen meditating upon the supreme compassion for which this Buddhist saviour was venerated.

This ruler, the last great king of Angkor, was instrumental in expelling the Chams, who had invaded from southern Vietnam and sacked a weakened Angkorian state following Suryavarman's death. Having spent several years resecuring the political integrity and stability of Cambodia before he claimed the throne in 1181, Jayavarman VII then set about expanding the territory of the empire and rebuilding the pride of Angkor. As a devout Buddhist, public deeds feature prominently in his reign. According to inscriptions of his reign, the king provided for the material good of his populace in a number of ways: he founded rest houses (*sala*) and a network of 102 hospitals, located across the empire. His Buddhist disposition did not prevent him however from waging protracted wars, nor embarking on a building programme of almost megalomaniac proportions, with all that that implies for the populace and workforce.

A prolific builder, Jayavarman is perhaps best remembered for two achievements. Firstly, the city of Angkor Thom with its great moated enclosure wall, grand causeways and spectacular multi-faced gates of Victories, which lead to the last great state temple of the Angkorian period, the Bayon. His second great achievement was in his support of the Buddhist monastic community (*sangha*) and associated acts of charity. The scale of these undertakings is remarkable by the standards of any era. The massive temple-monastery of Ta Prohm which, according to its inscriptions was originally called the 'king's monastery' (Rajavihara), was designed to engage a community of over 12,000 people, supported by agrarian lands and a farming workforce of nearly 80,000. The temple complex of Preah Khan, dedicated in 1191 to Lokesvara, was another massive undertaking, designed to support an even larger

community. It appears to have been a centre of religious learning, engaging over a thousand gurus. Shrines dedicated to family members who were worshipped as protectors of the royal house form part of the complex, as do shrines devoted to Hindu deities.

Jayavarman VII had inherited a fractured and rebellious empire, and took care to re-establish the system of highways which linked Angkor to its provincial capitals in northeast and central Thailand. This allowed him to enforce loyalty and prevent a repeat of the political fragmentation of the empire. The highway from Angkor to Pimai, near Khorat, can still be traced. He installed what are presumed to be portrait sculptures of himself at key centres throughout the empire – examples have been recovered not only at his state temple of Preah Khan and elsewhere at Angkor, but at such distant Khmer centres as Pimai and Lopburi in modern Thailand.

The overtly political nature of temple building at Angkor was a constant factor. In Jayavarman VII's final great state temple, the Bayon (c.1200 onwards), this is made newly explicit in ways that integrate his political agenda with the imagery of his religious beliefs. The Bayon is, in its essential form and fabric, a cosmic mountain, like all those state temples that had come before. But because of its Buddhist intent, and the protecting role that the bodhisattva of compassion, Avalolitesvara (Lokesvara) fulfils, it takes on another dimension as a protective energy-centre for the whole Khmer state. The Buddha properly occupied the central sanctuary, and a complex system of secondary shrines, part of the original conception, were occupied by ancestral deities and the gods of lands conquered or which acknowledged Angkor's suzerainty. In this way the Bayon served as a pantheon of the nation's deities, presided over by the massive multi-directional faces of Lokesvara.

No doubt Buddhist monks and Hindu *rishis* and gurus travelled Jayavarman's highways to the capital, to participate in the religious life there. By the fourteenth century the shift to Theravada Buddhism, the school of Buddhism widely practised in mainland Southeast Asia today, was well underway. Pali inscriptions, the preferred language of this school, begin appearing from the beginning of that century. Monasteries of monks have been in continuous residence at Angkor ever since, despite the Khmer royal family abandoning the city in favour of Phnom Penh in 1431.

Buddhist pilgrims continue to visit Angkor today, along with travellers and tourists from all over the world. In his photographs Steve McCurry presents Angkor as a collection of living monuments. He peoples the sites in ways that animate and give scale and meaning to the narrative reliefs and the meditative silhouettes of the presiding deities. Unlike so many of the photographic record-makers at Angkor, McCurry has the vision and technical virtuosity to engage with the human dimension. He succeeds in entering into the actions of his subjects, reminding us of the human presence associated with these stone monuments, and of the memory of their makers and worshippers.

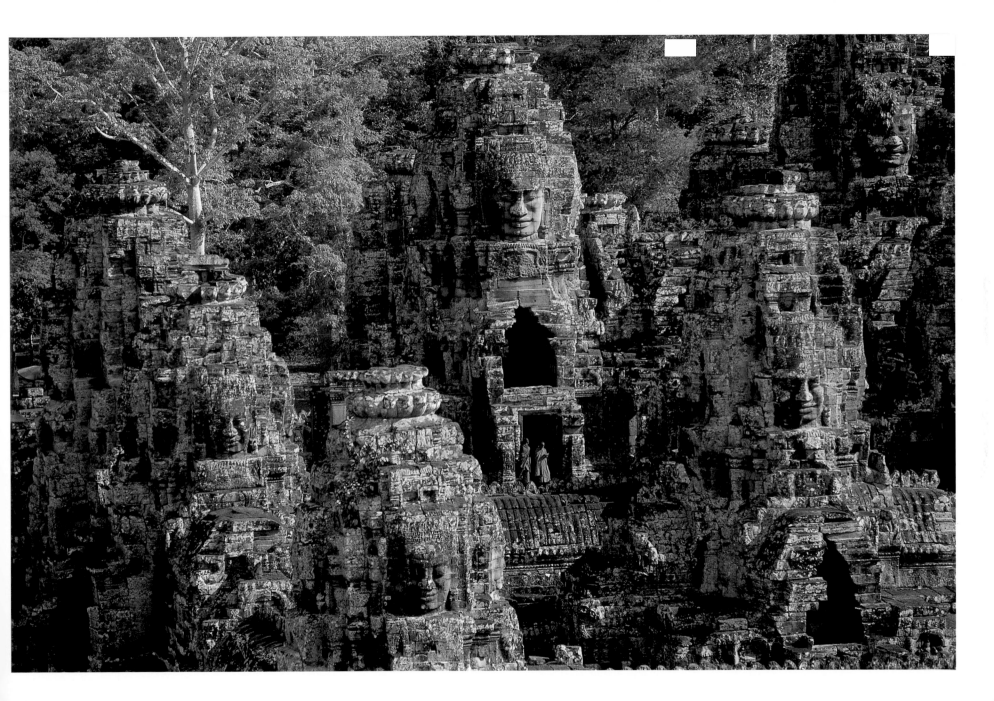

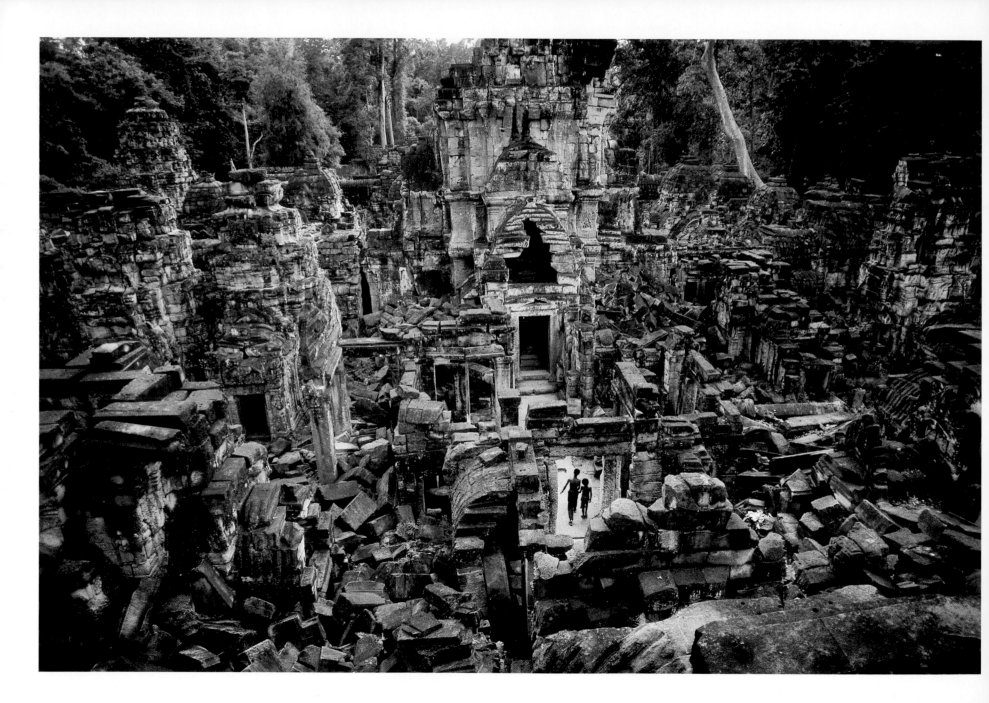

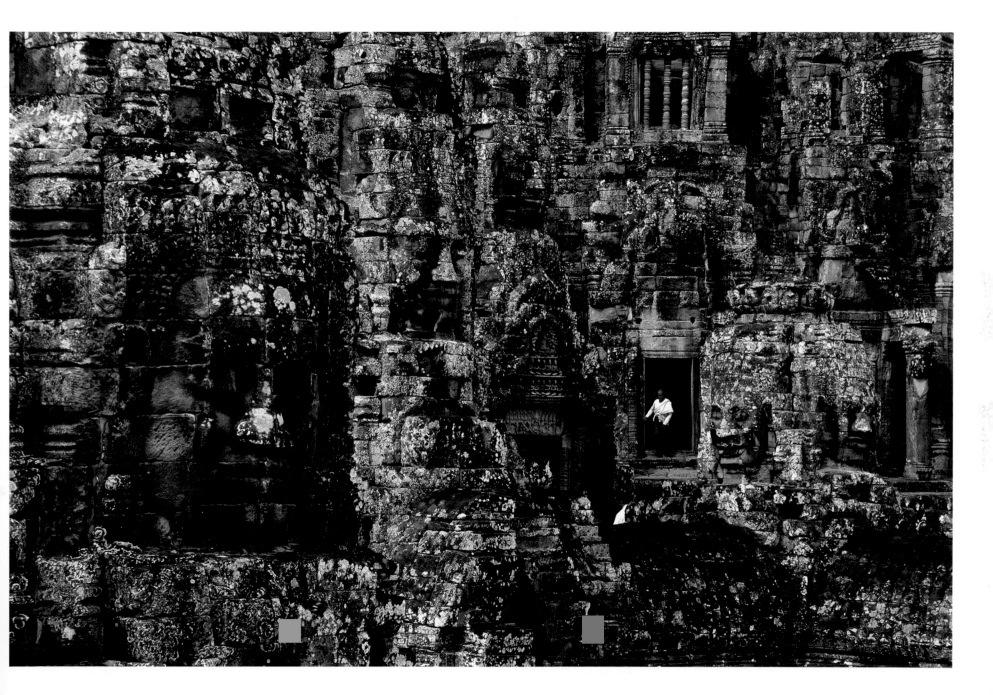

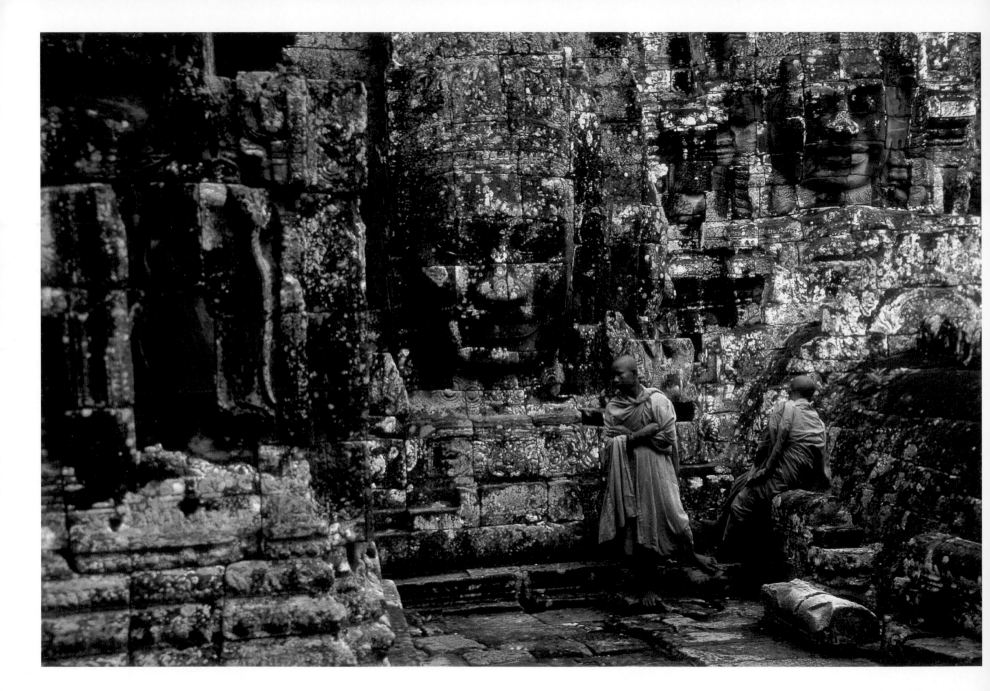

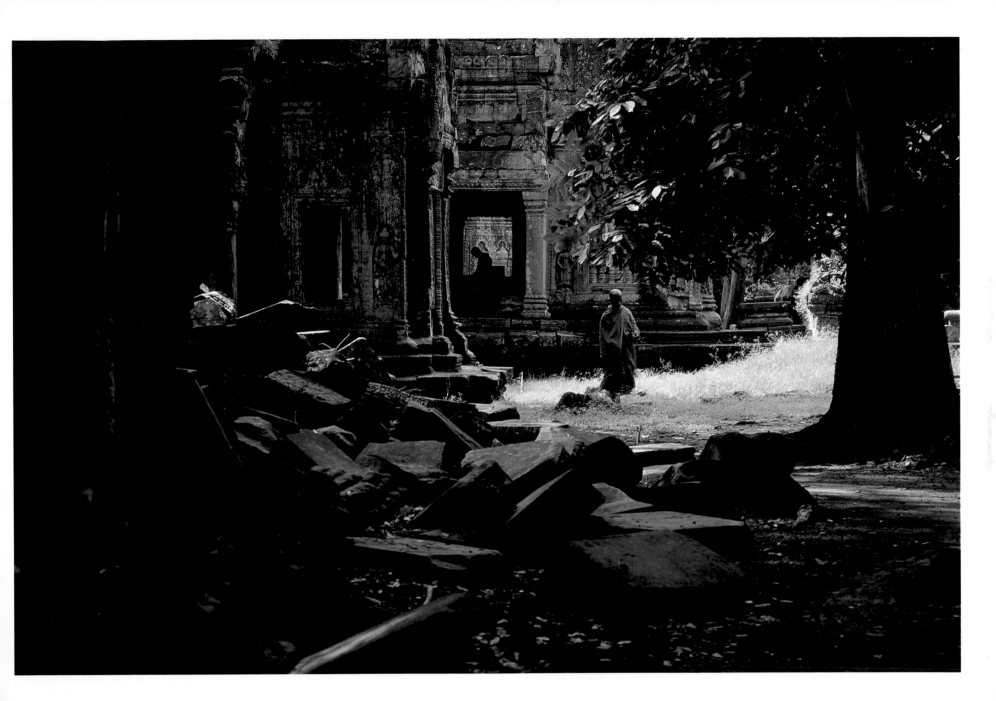

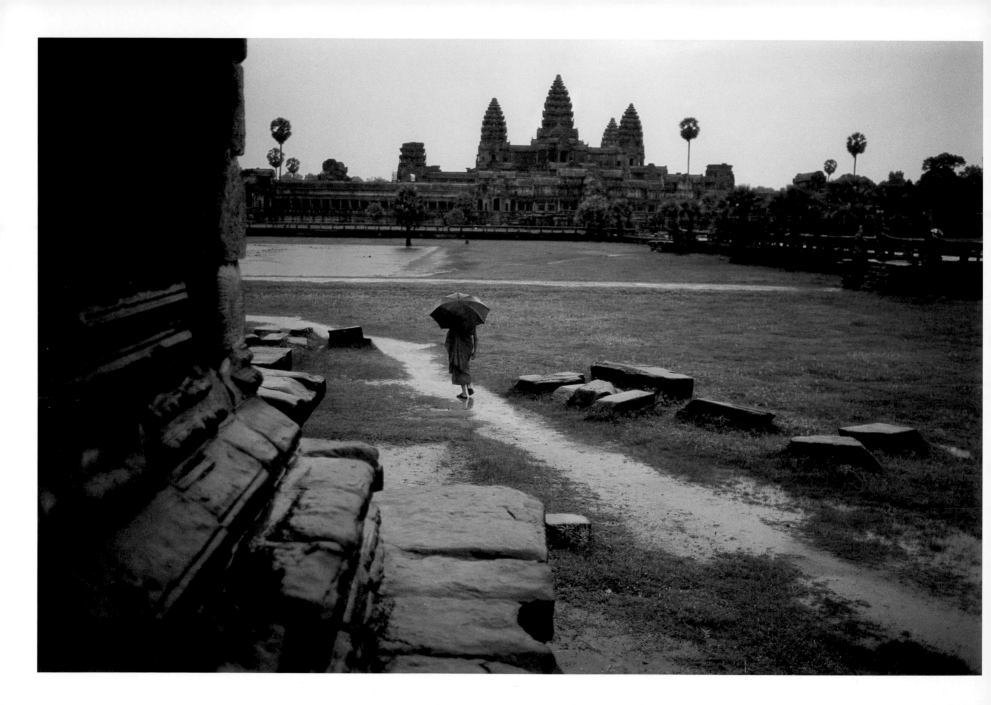

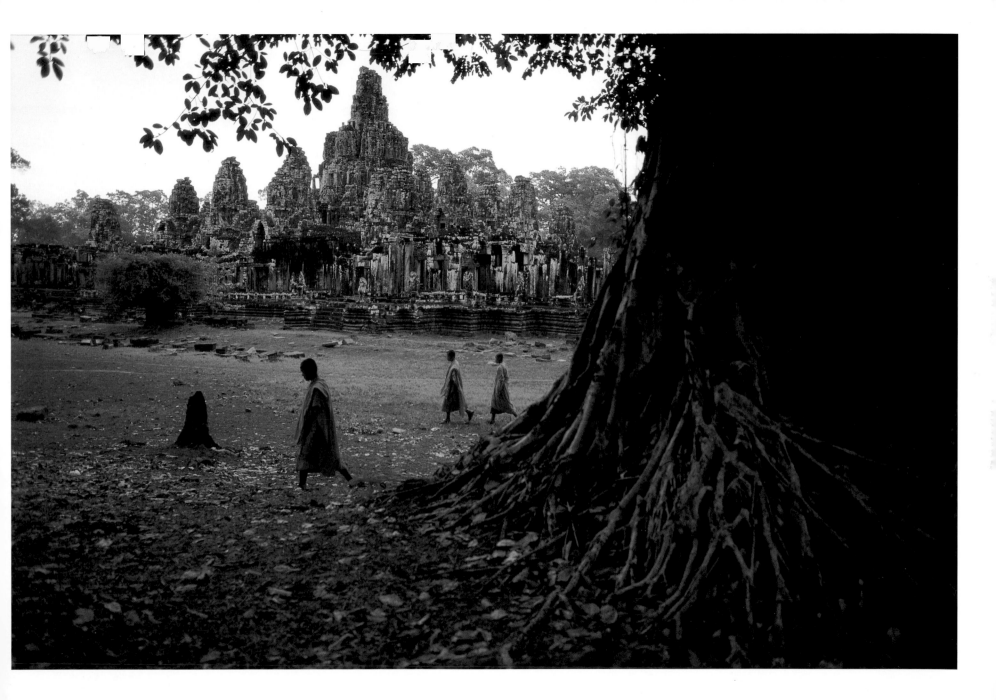

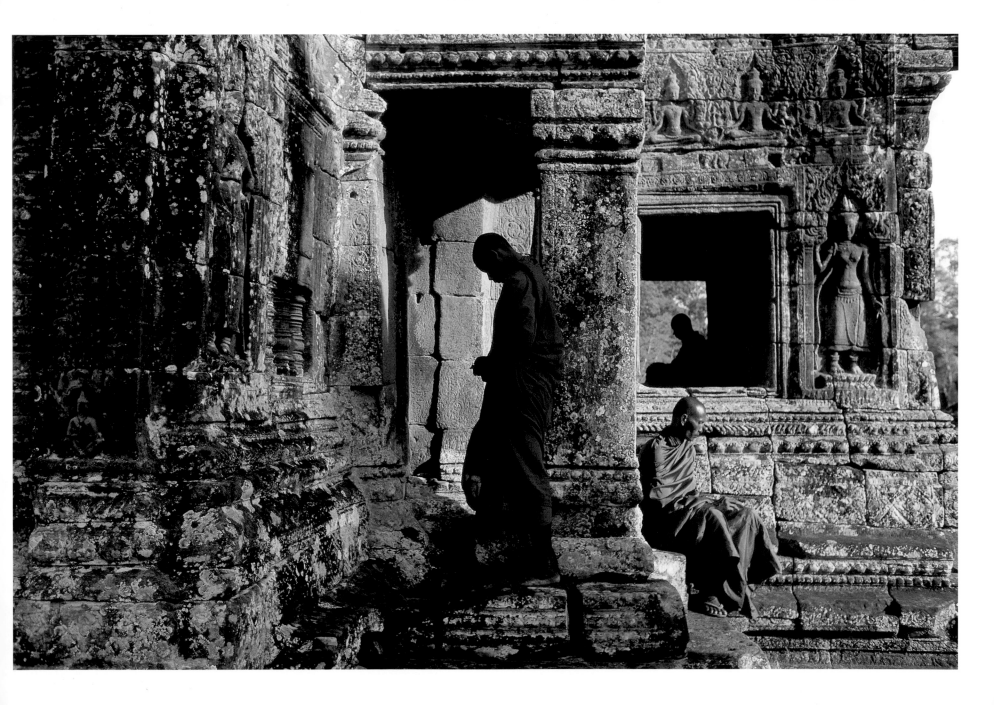

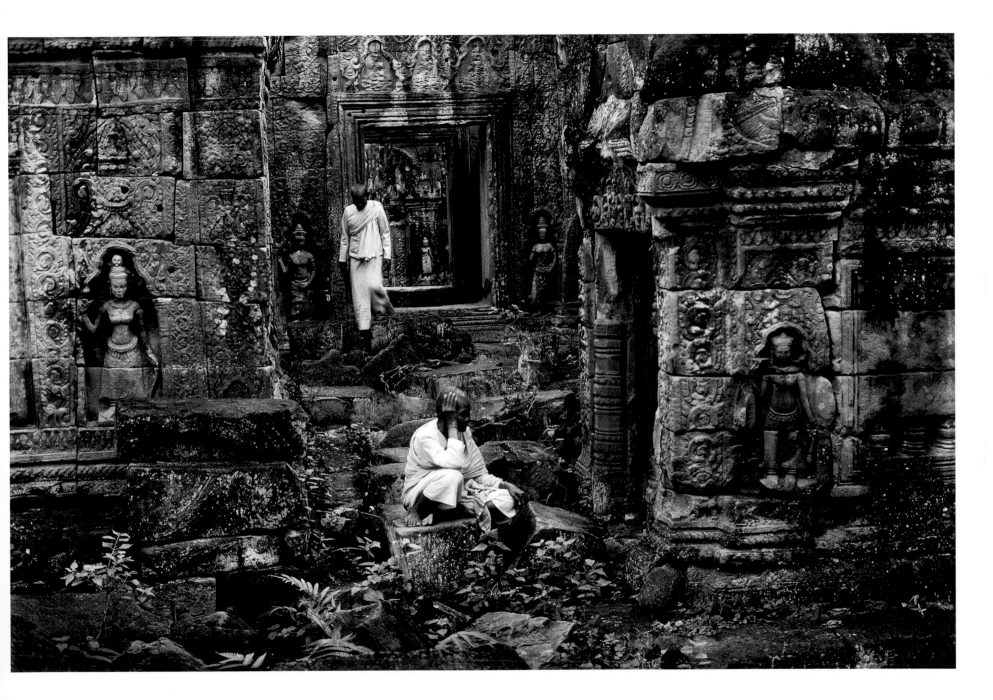

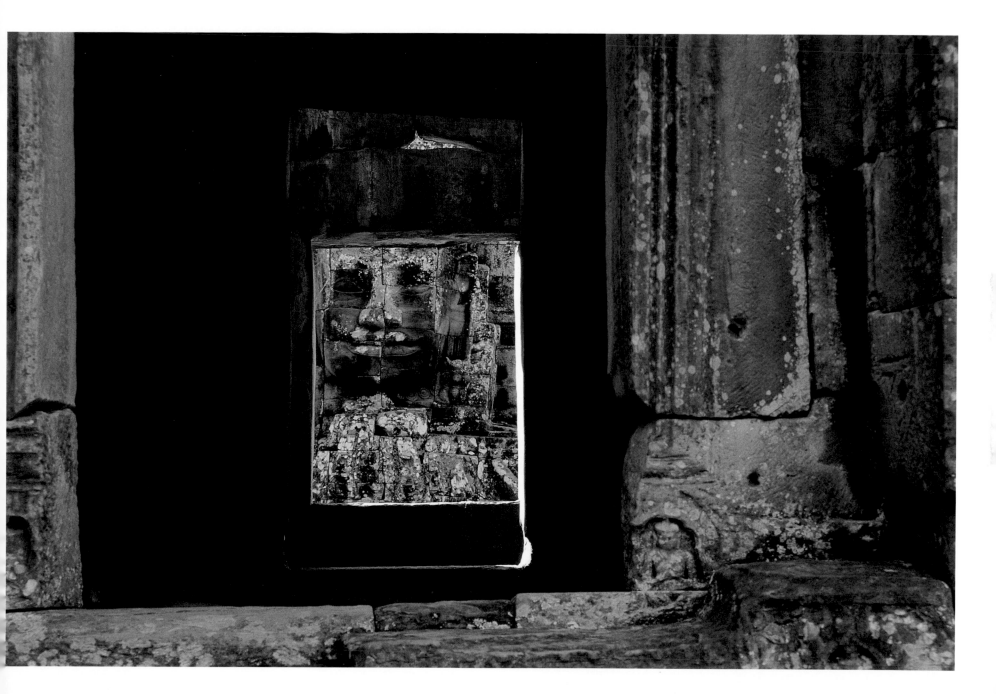

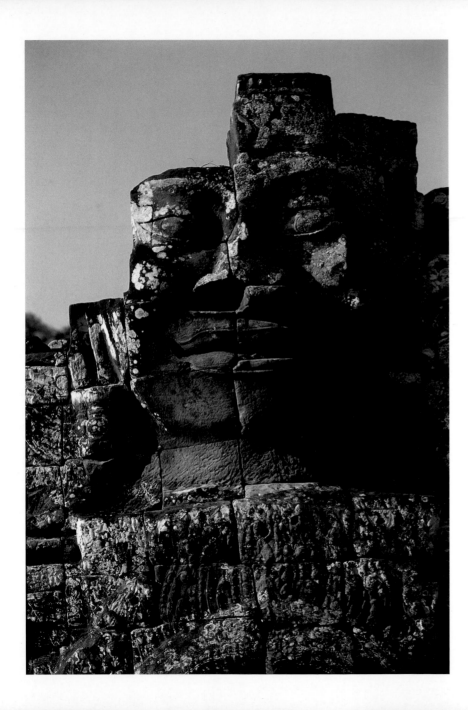

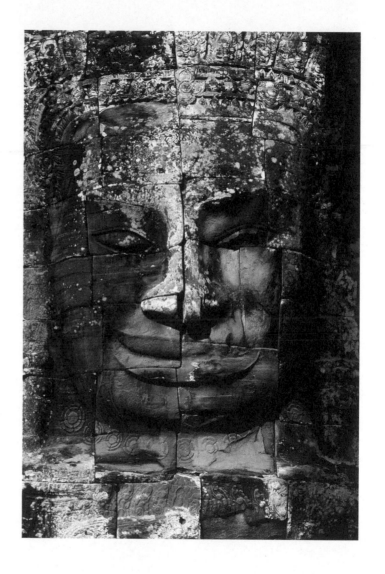

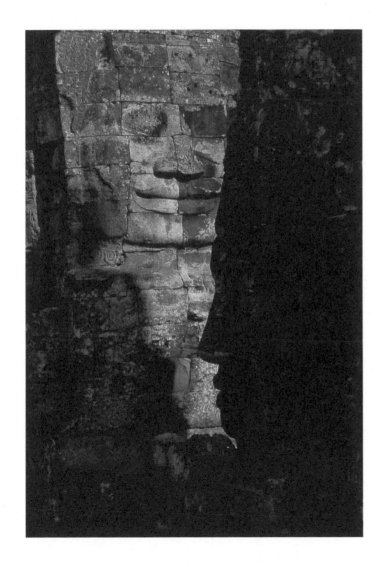
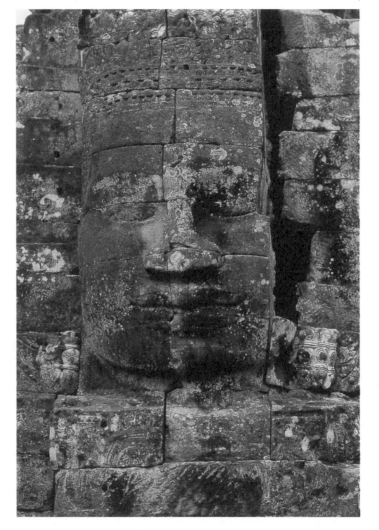

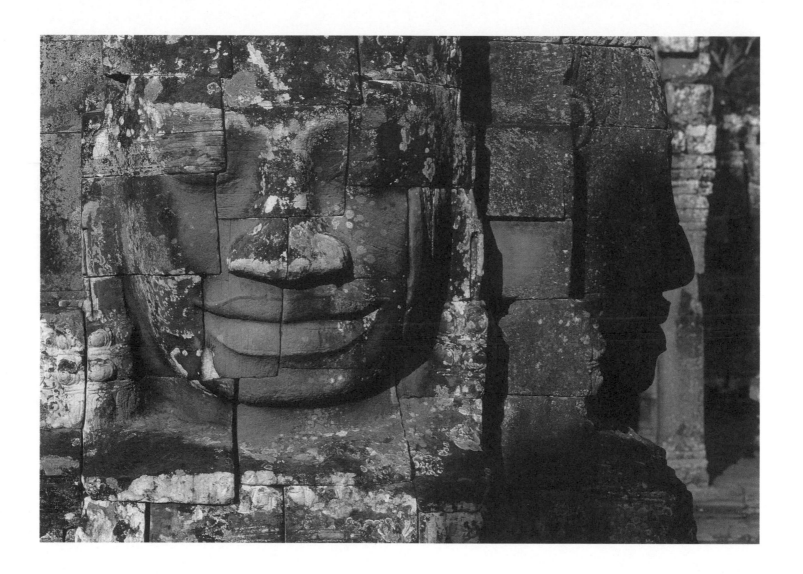

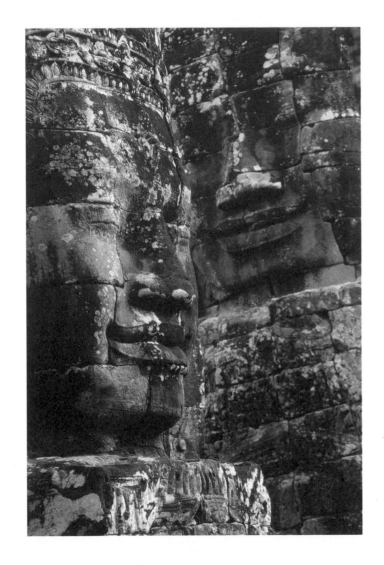
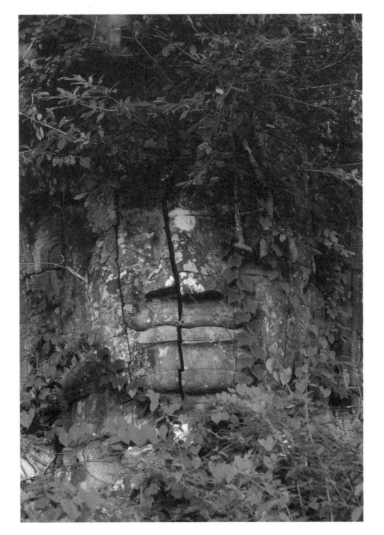

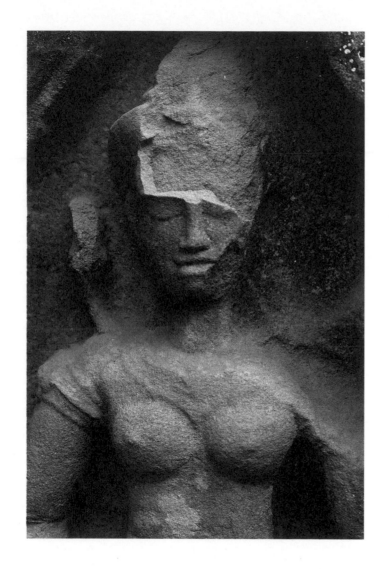

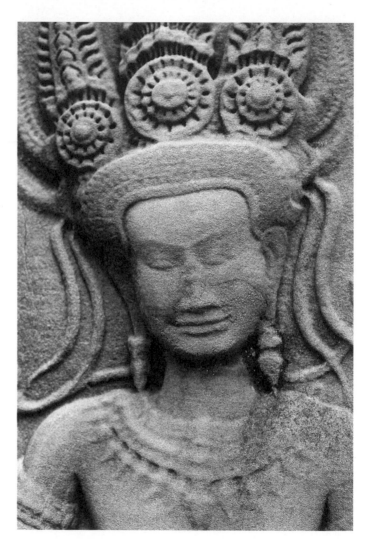

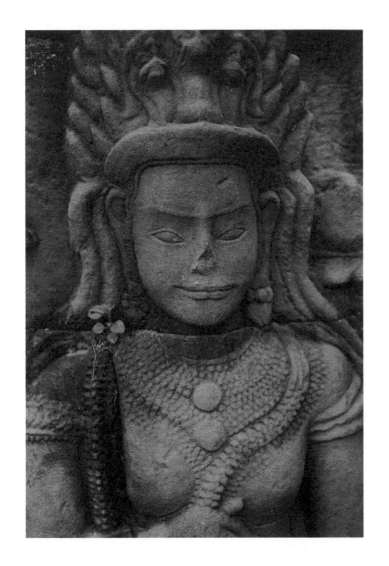

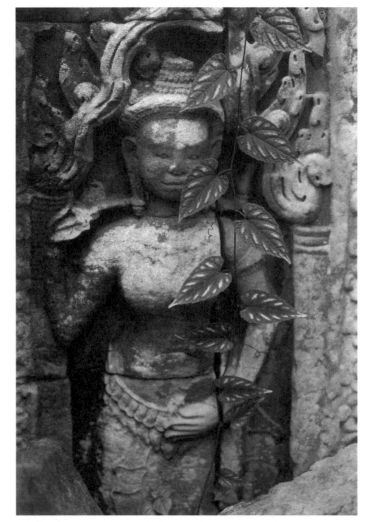

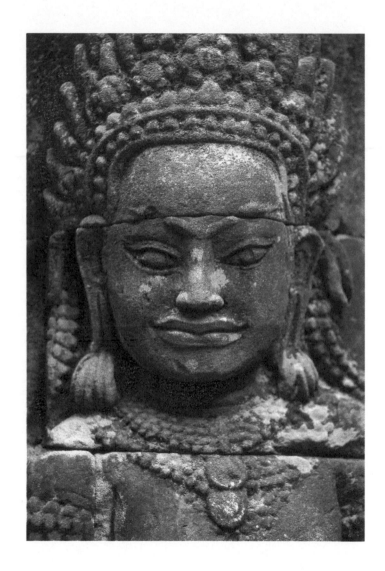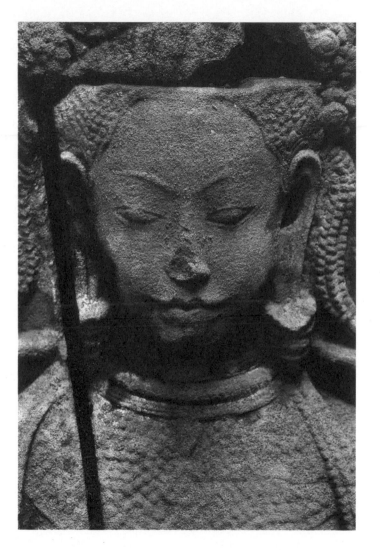

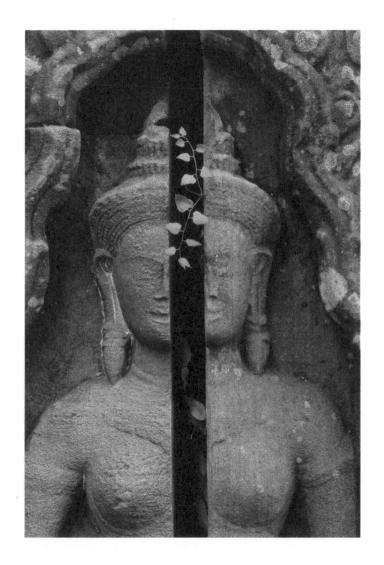
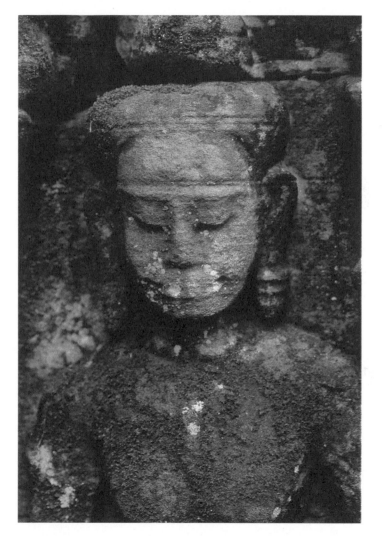

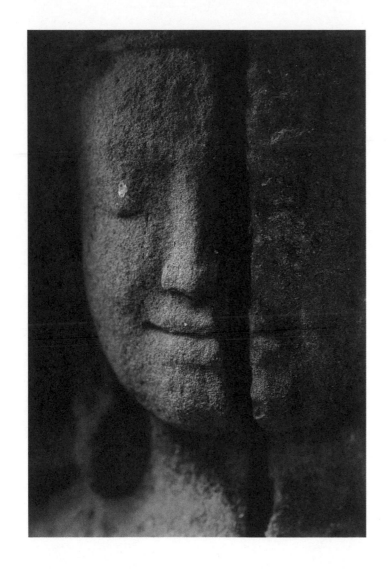

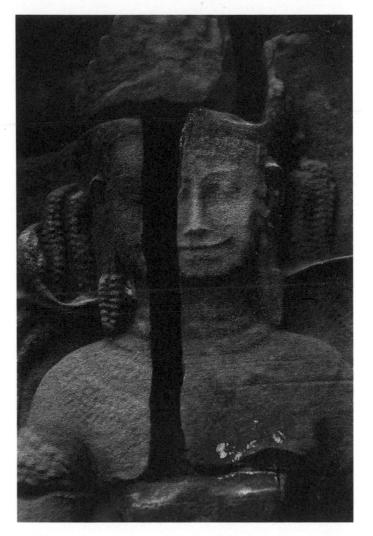

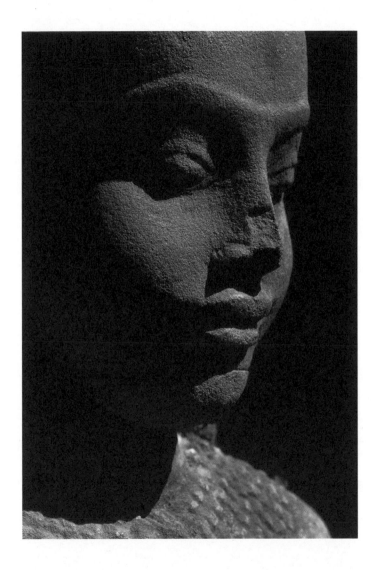

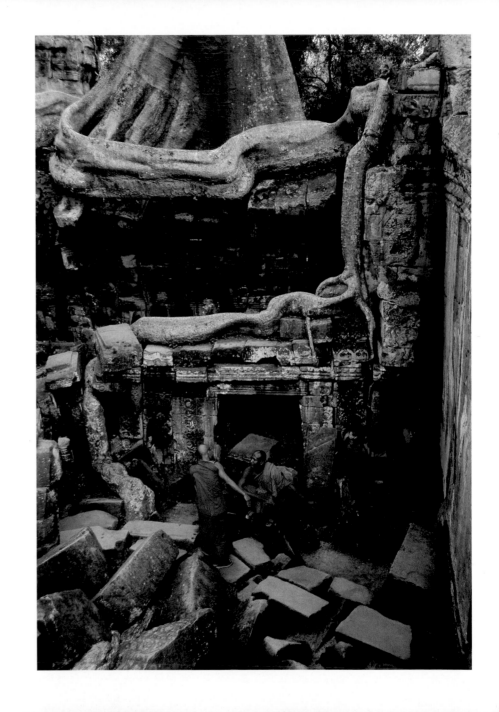

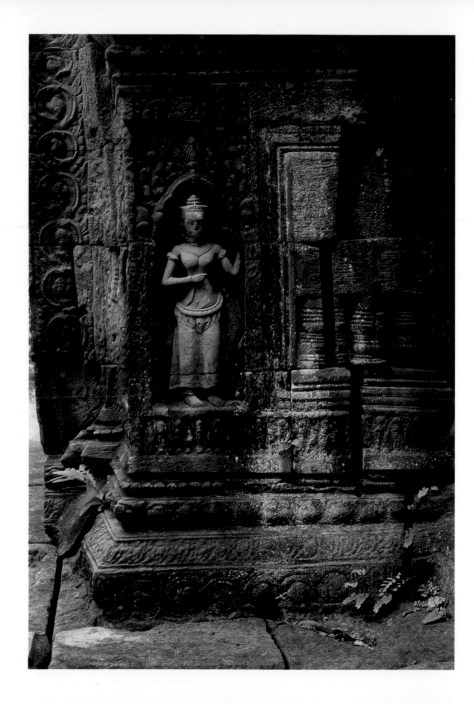

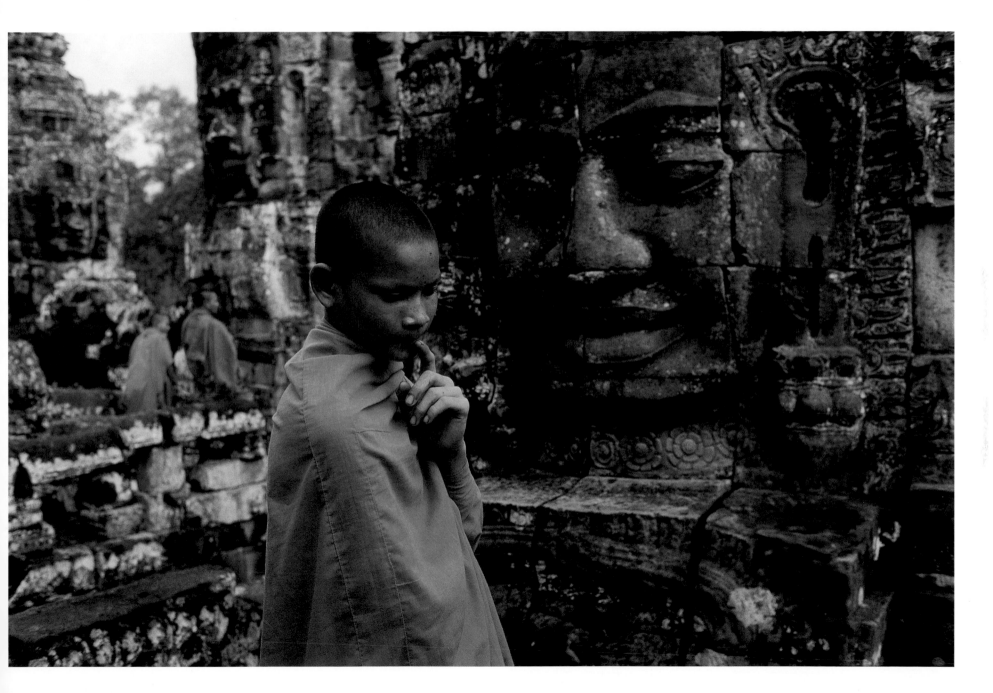

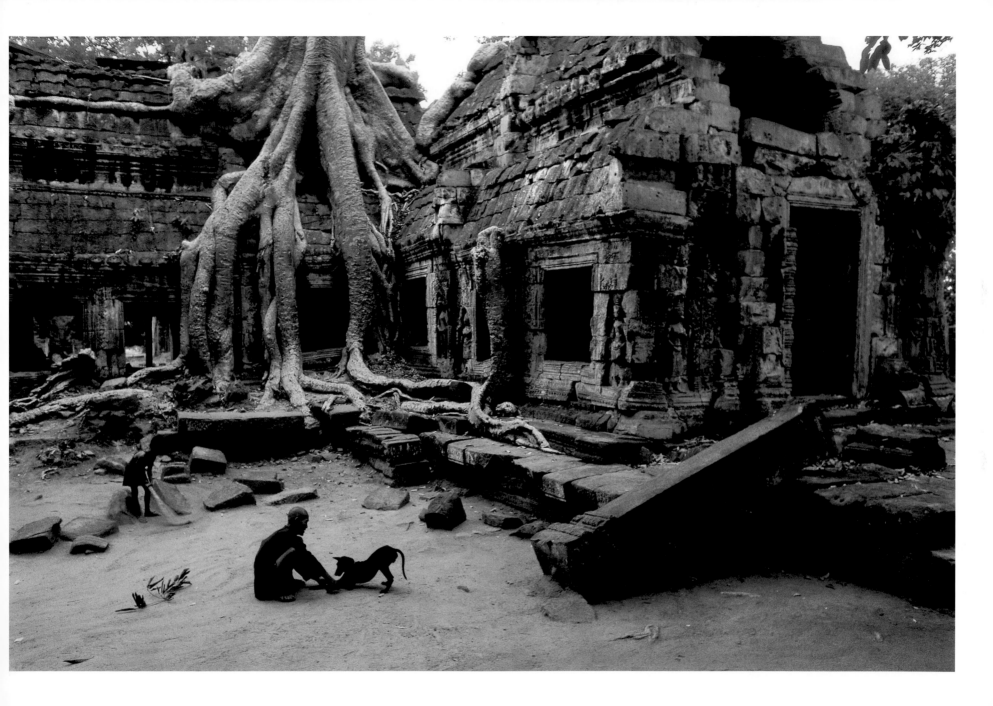

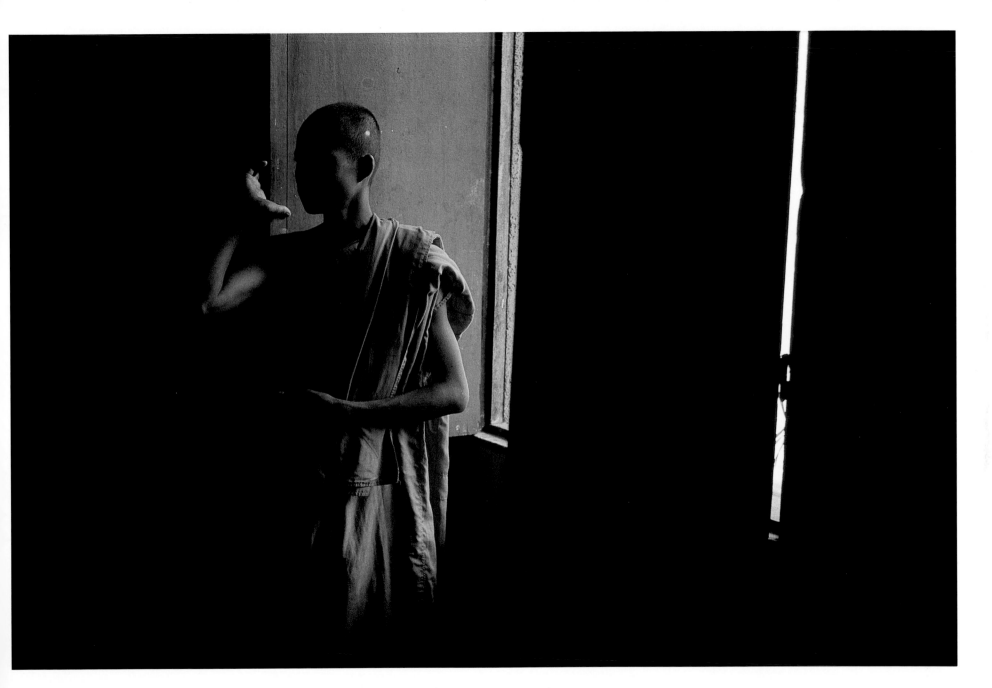

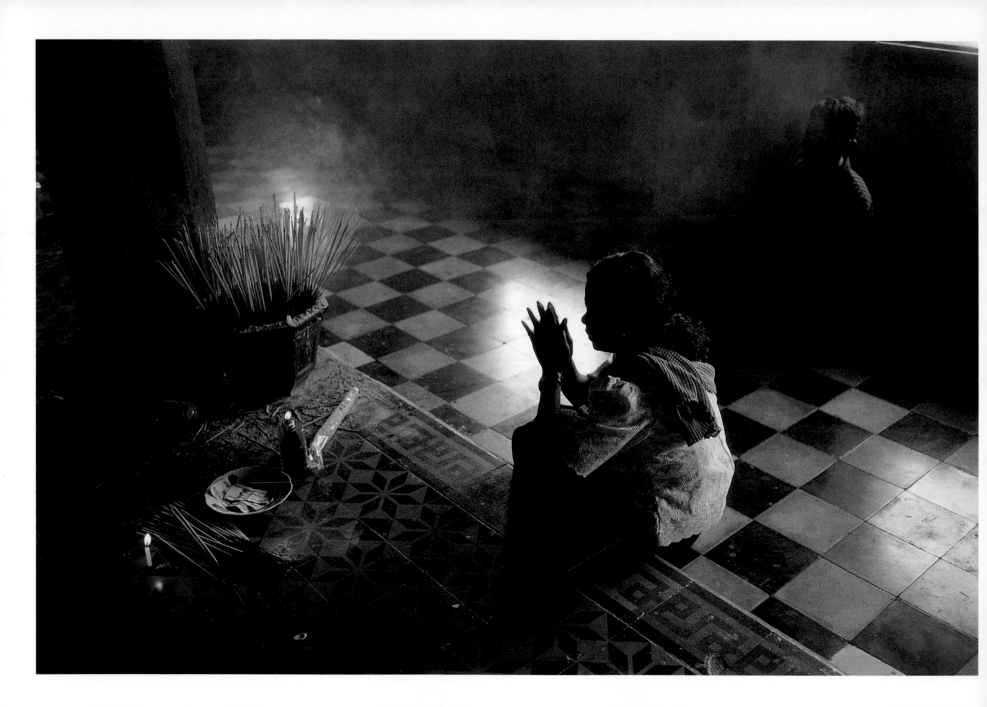

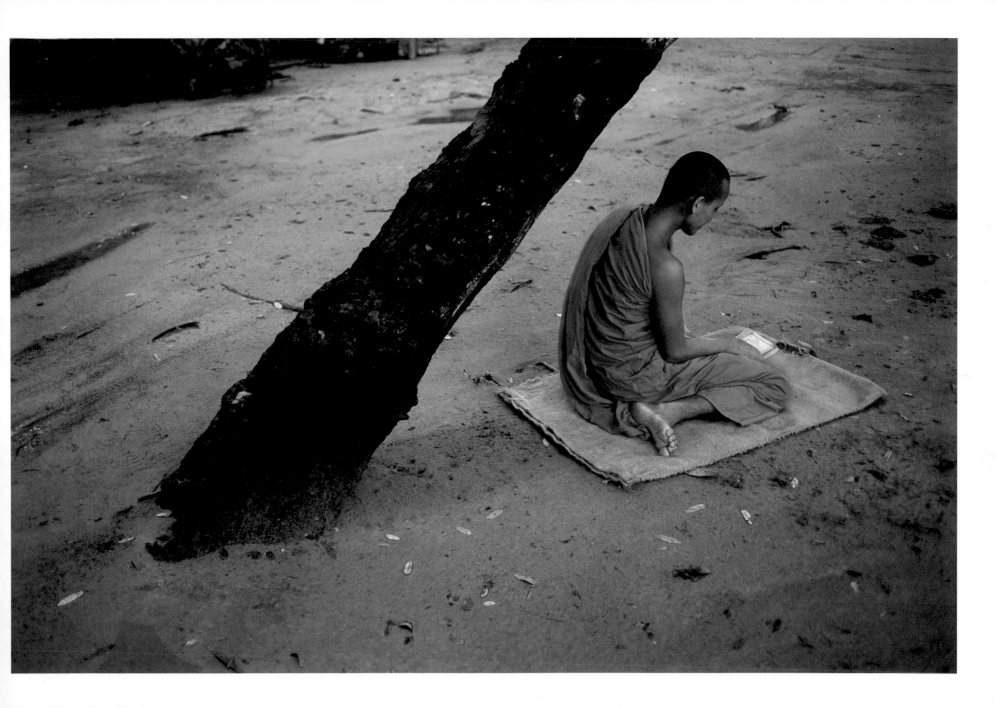

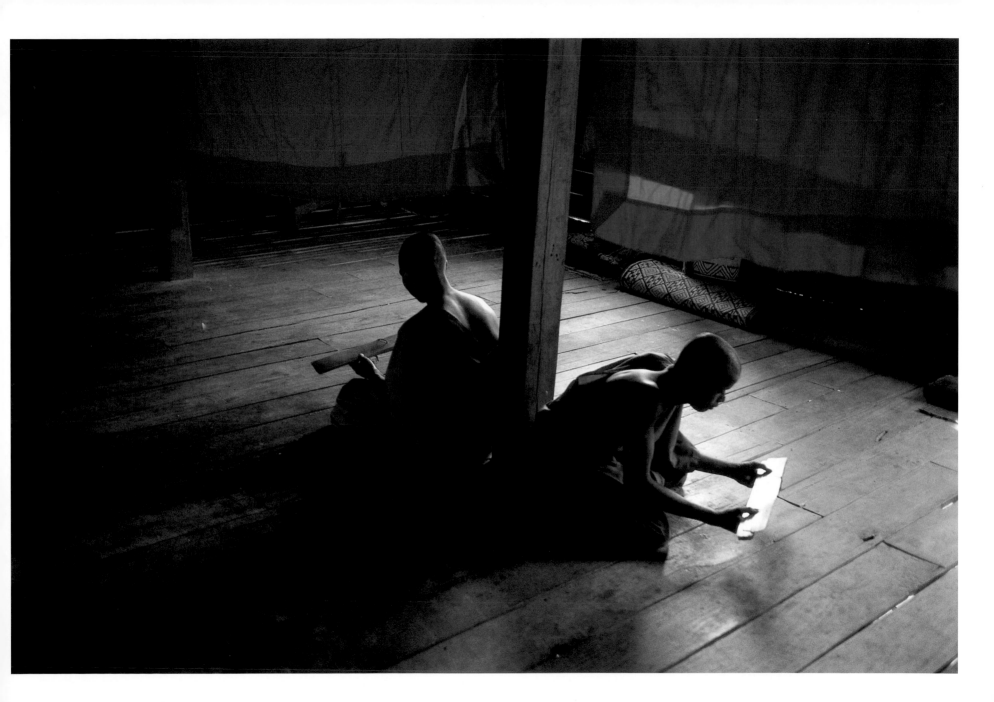

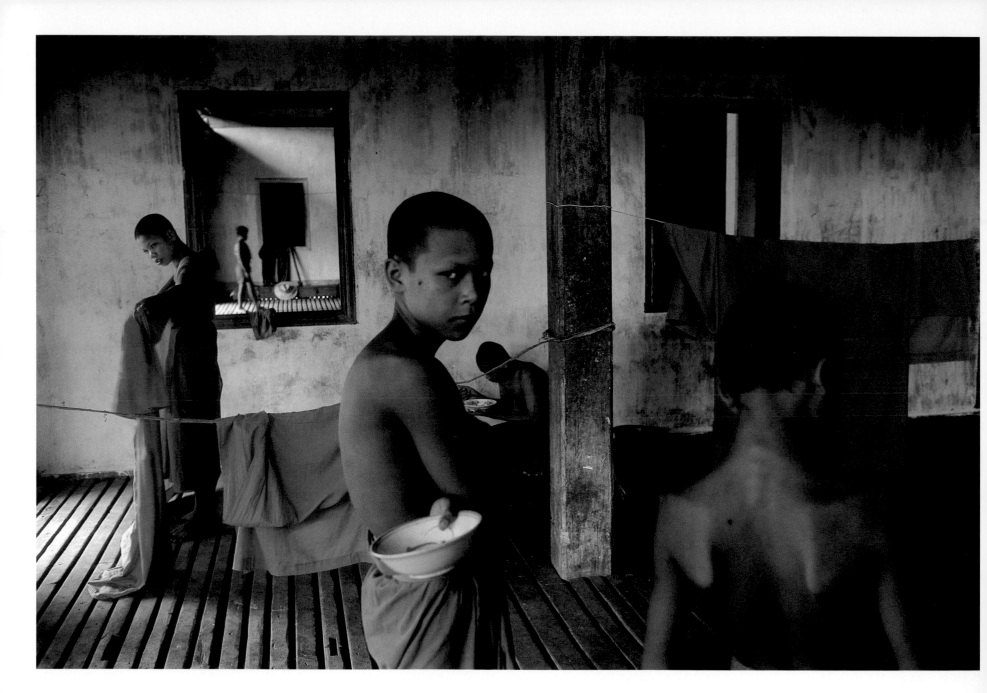

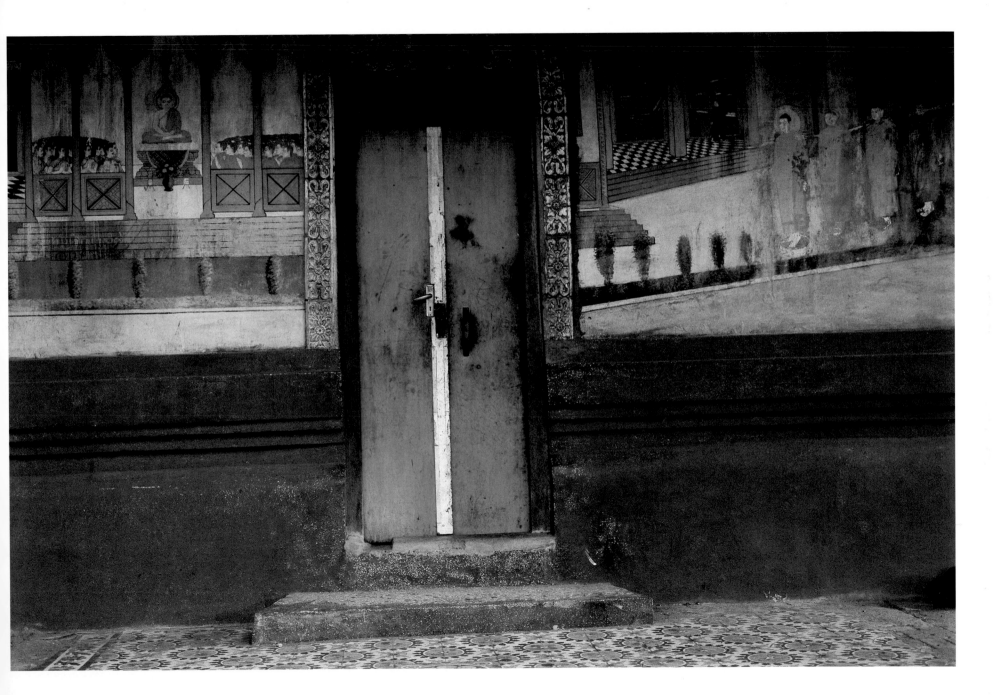

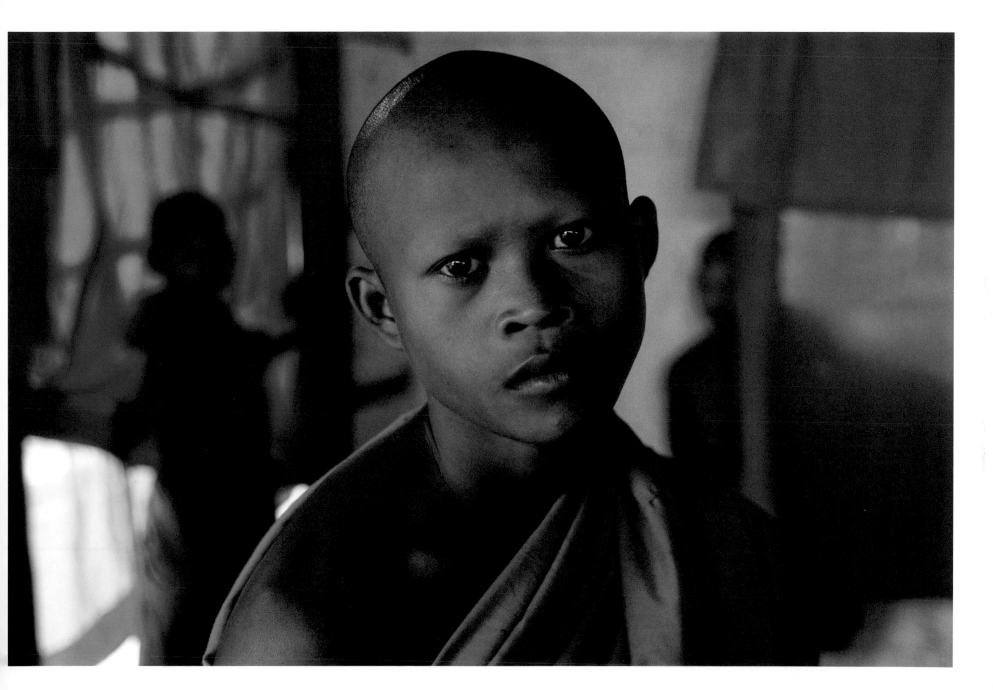

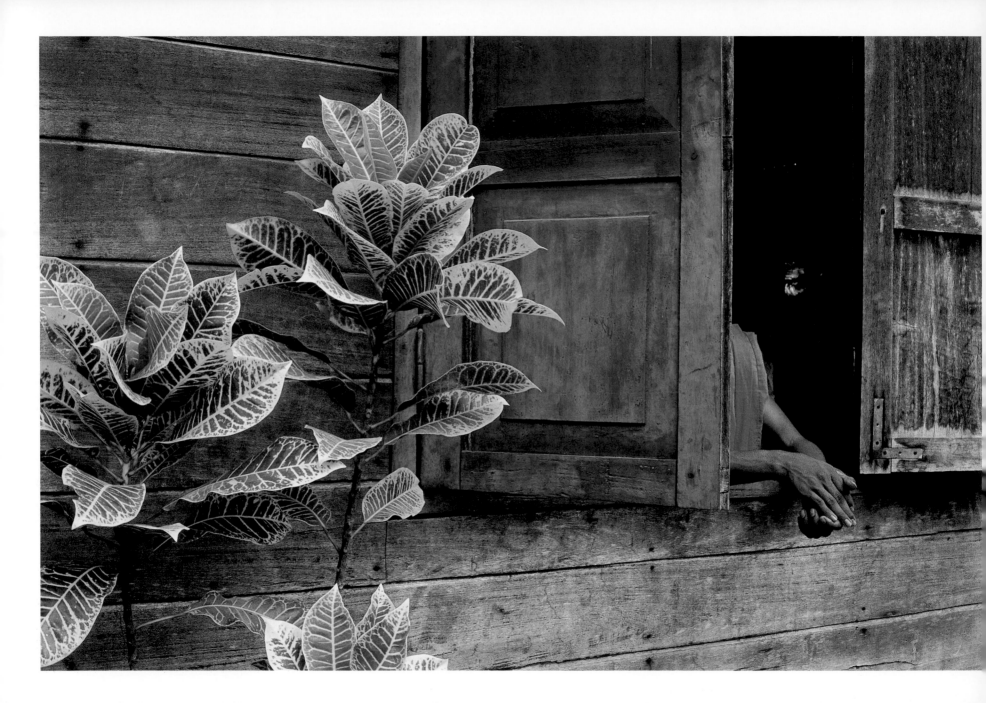

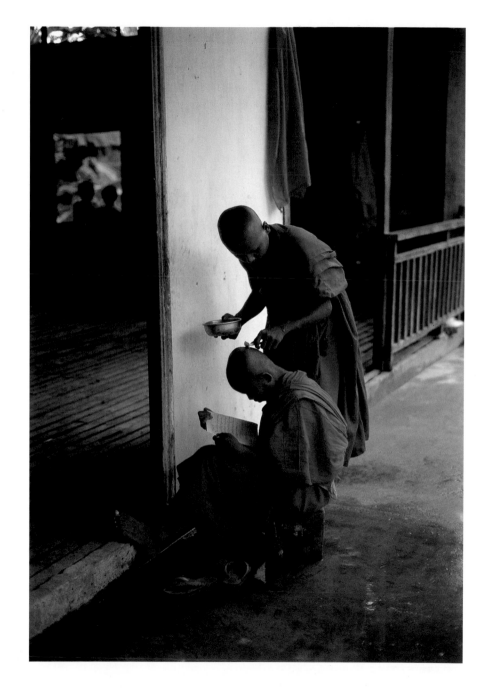

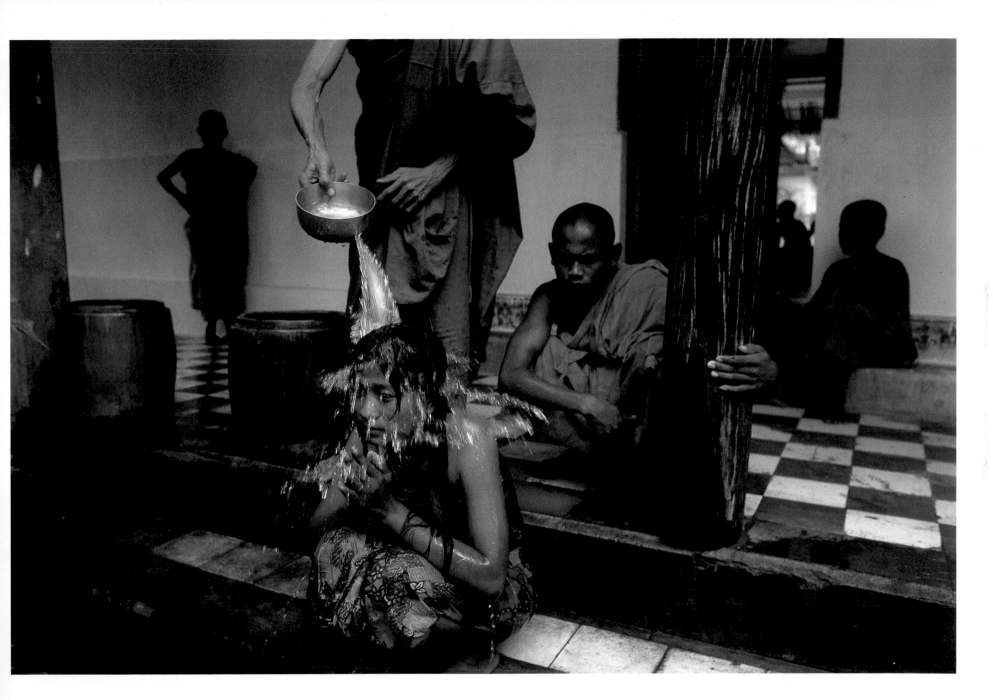

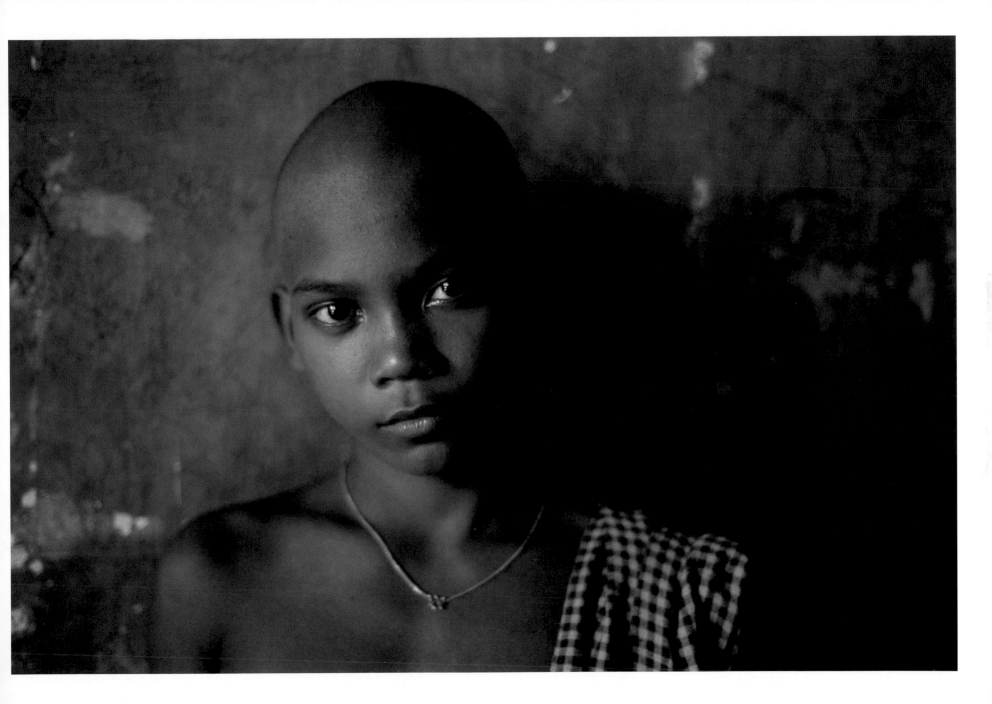

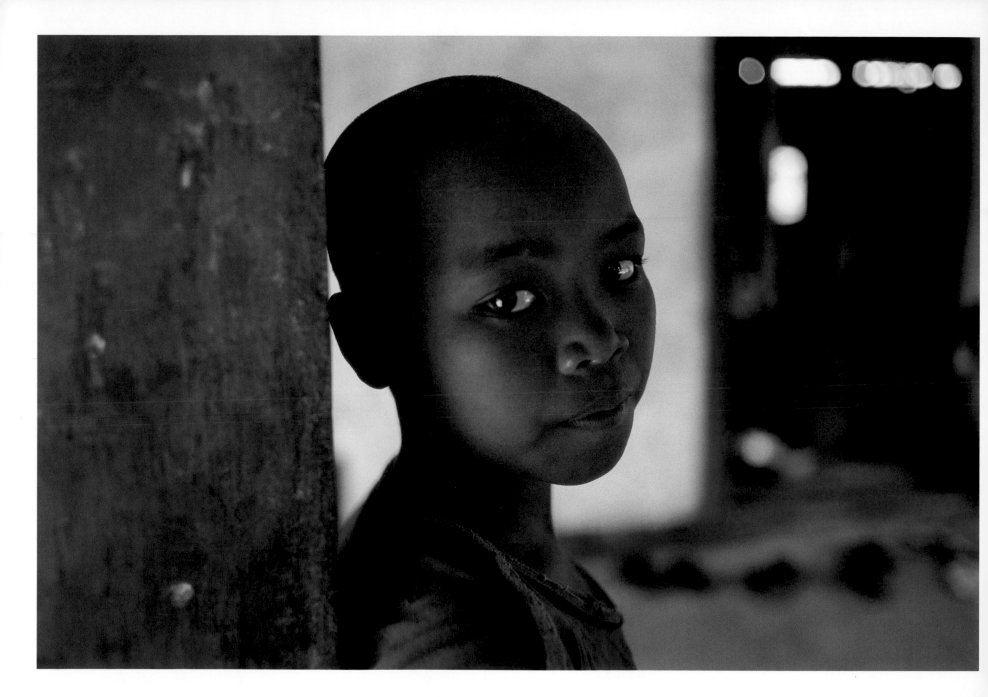

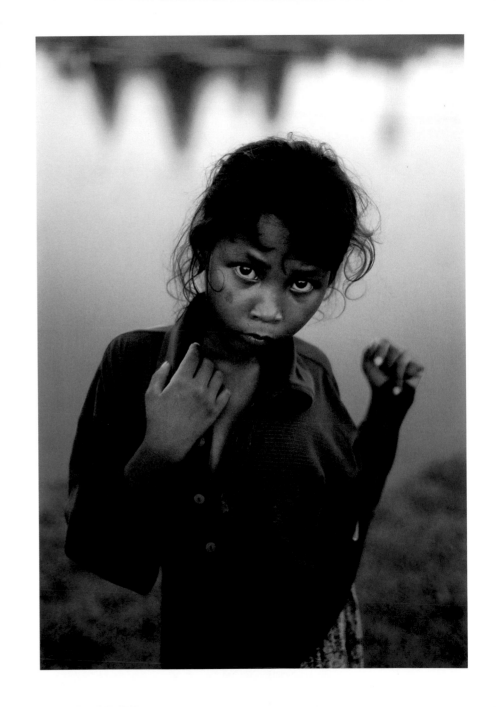

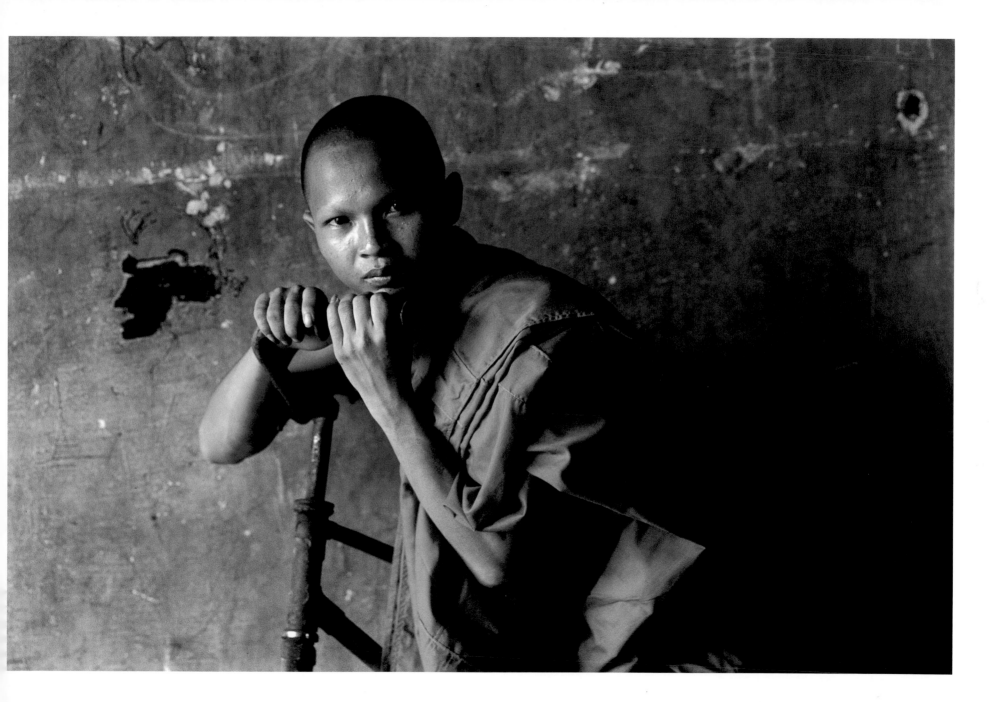

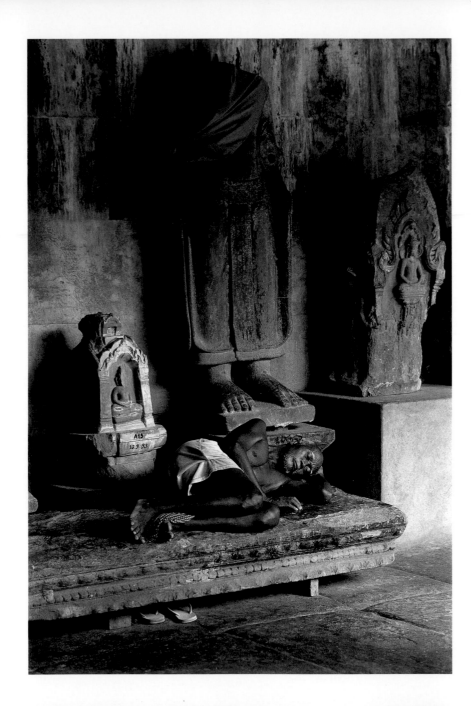

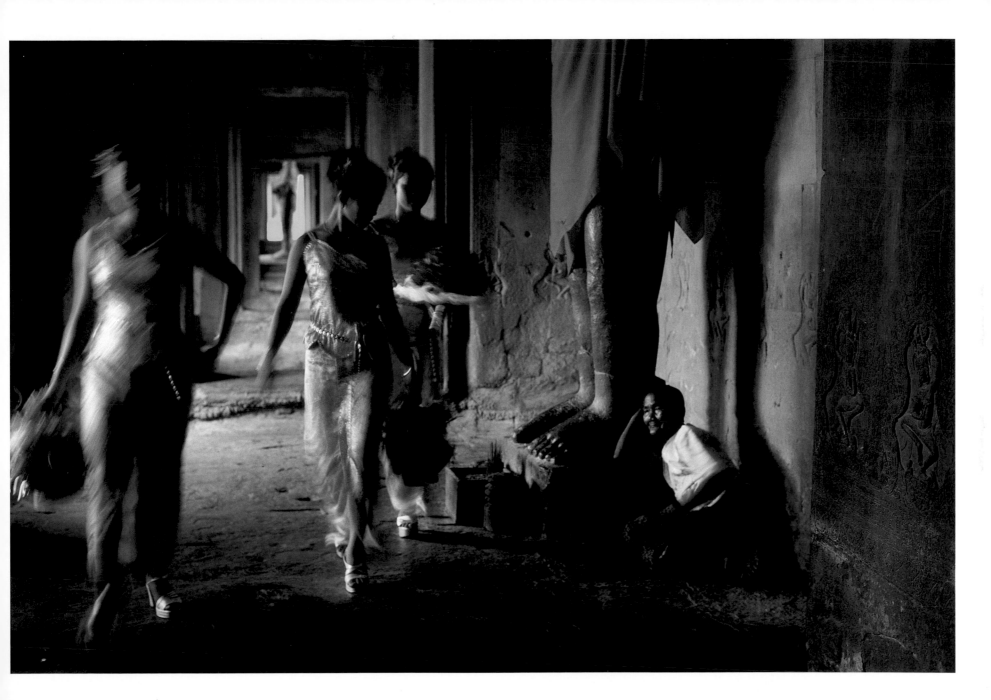

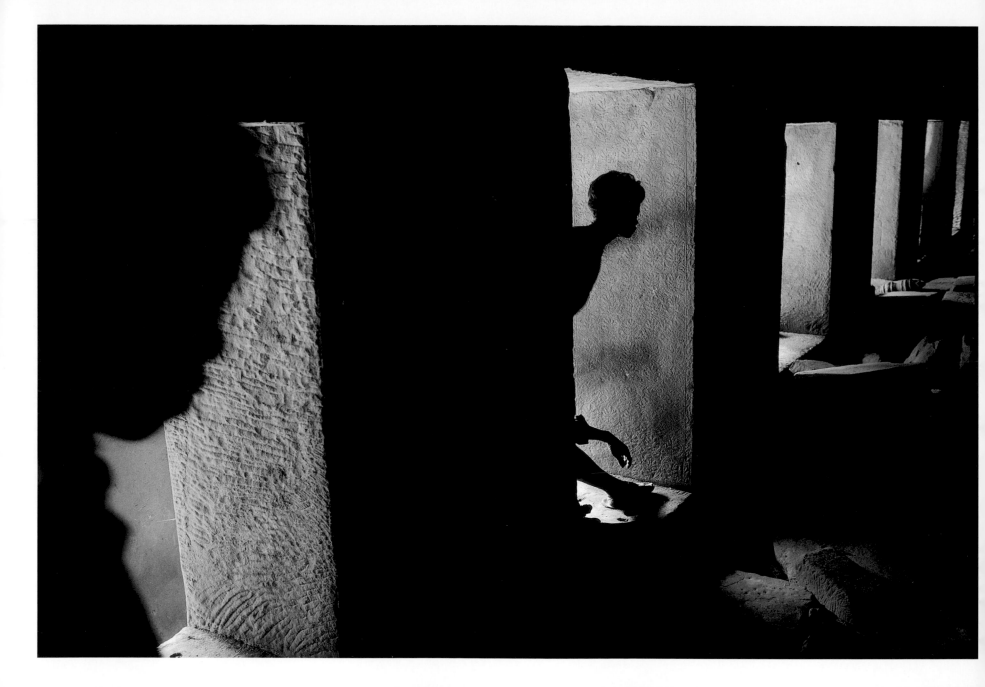

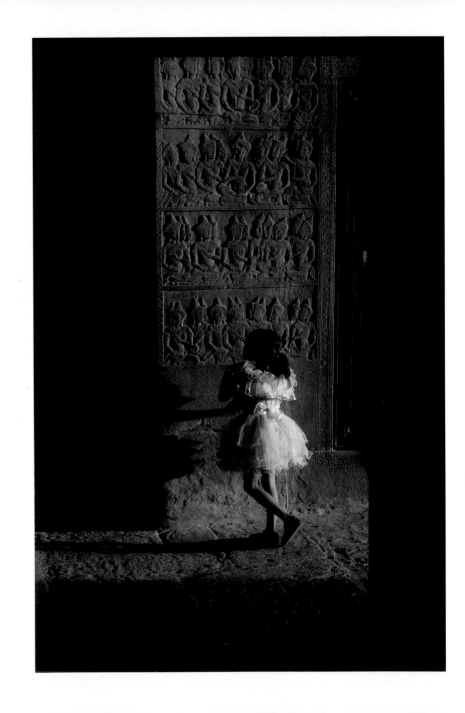

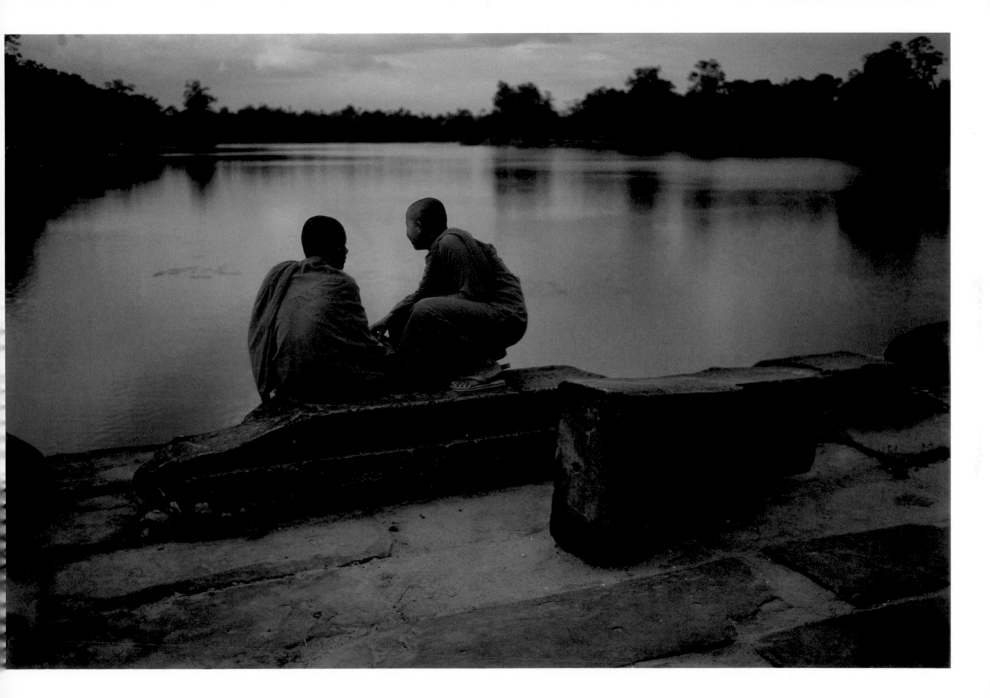

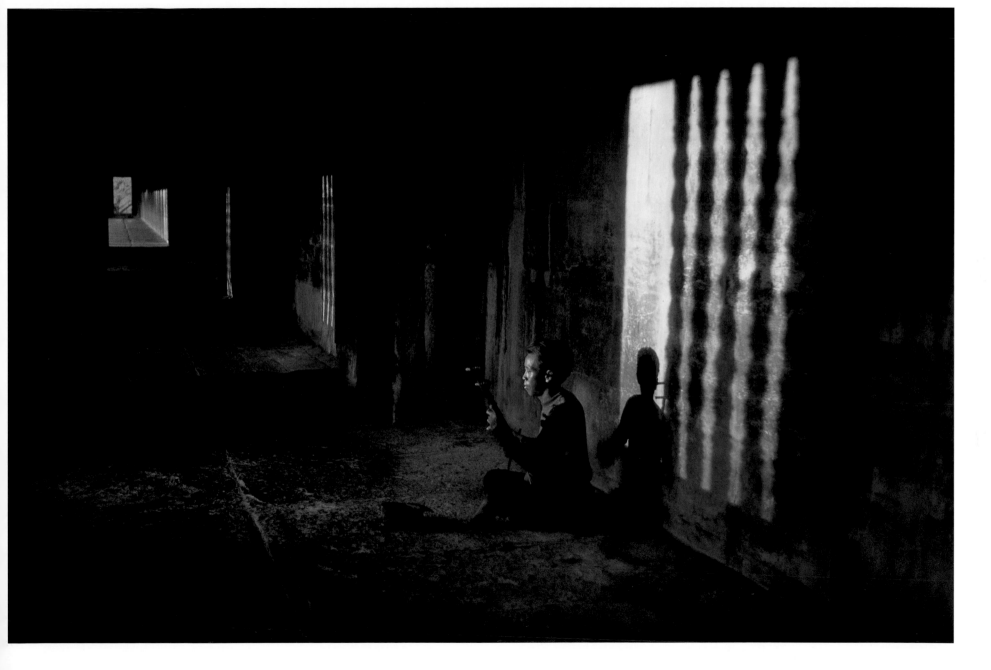

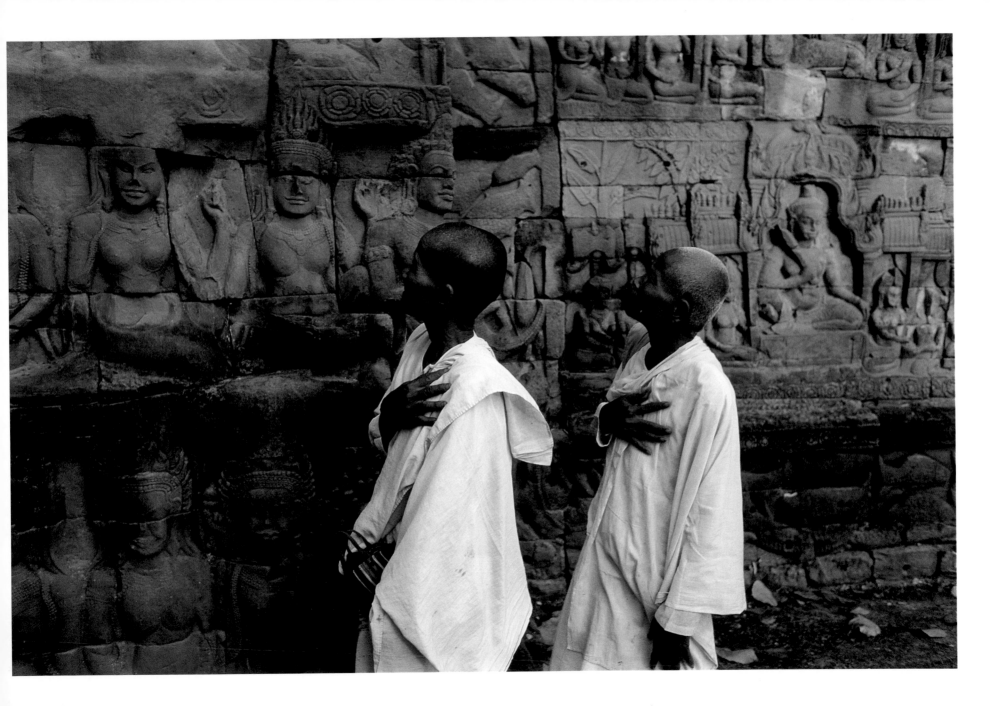

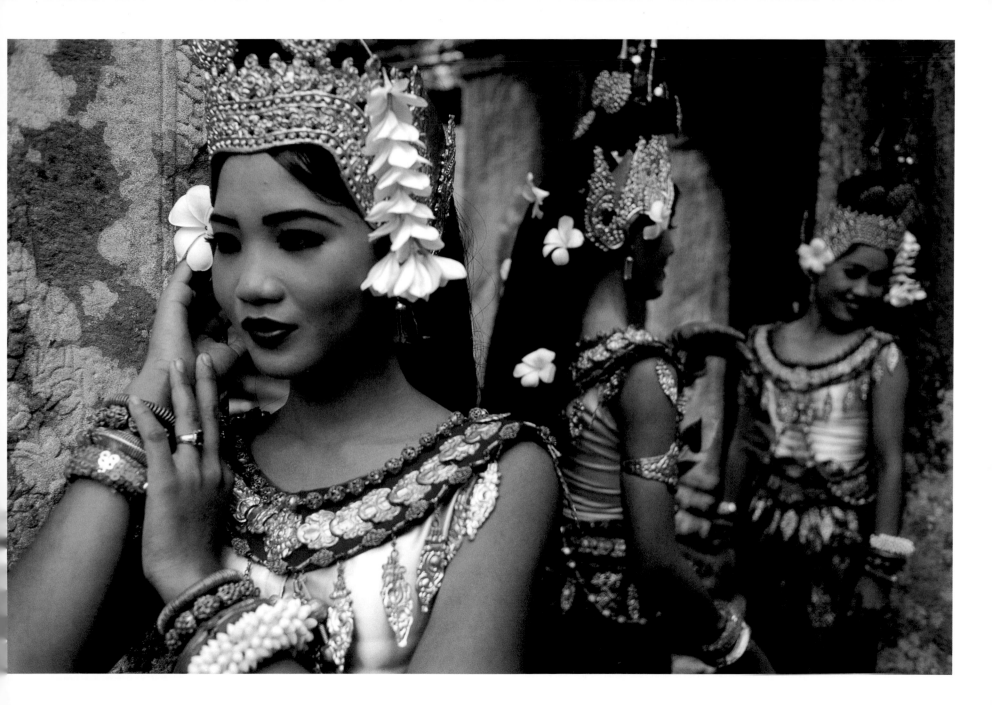

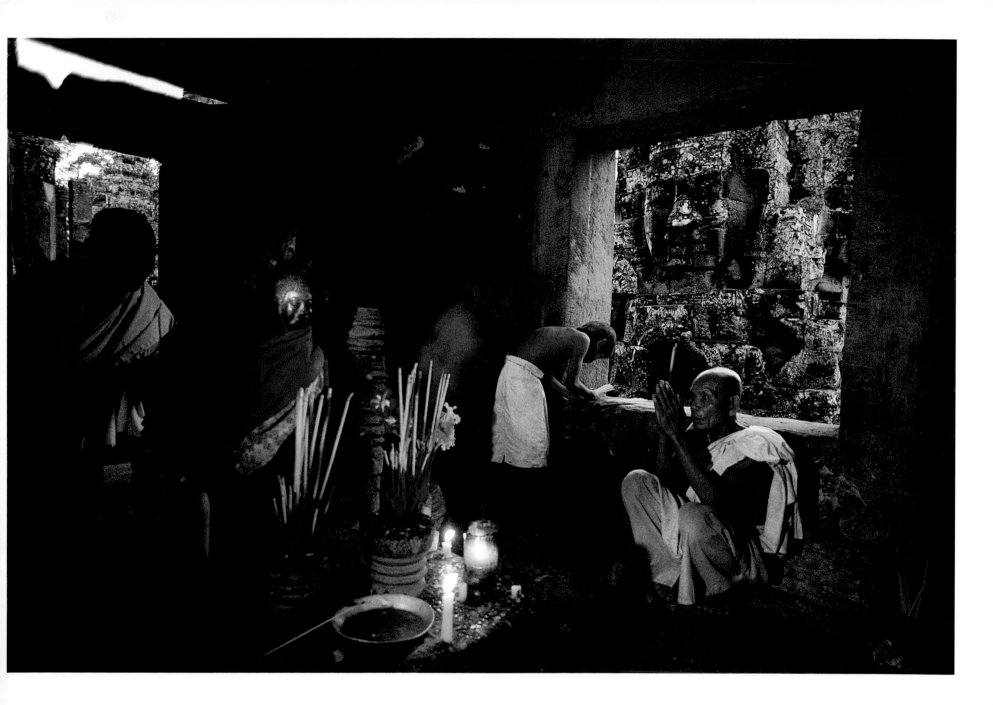

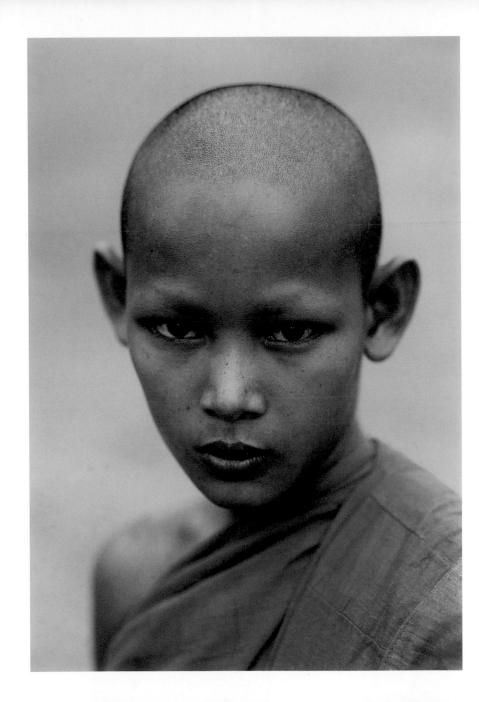

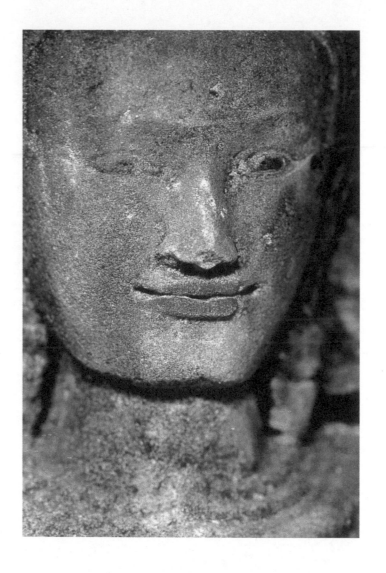

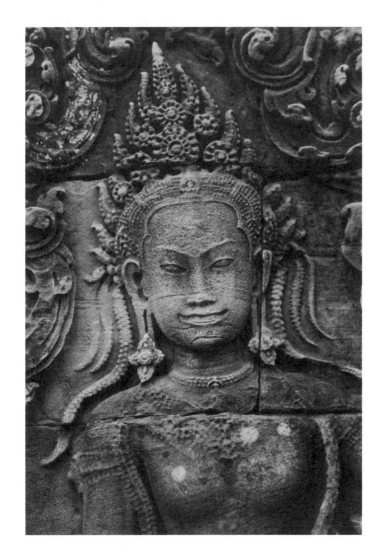
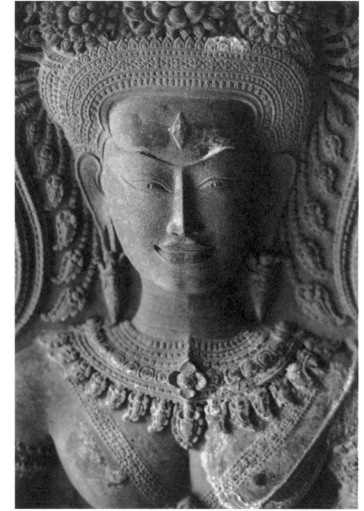

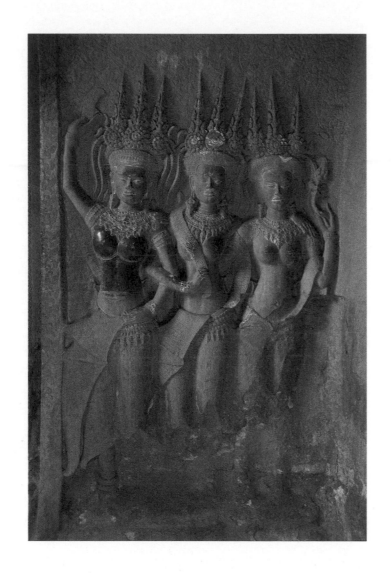

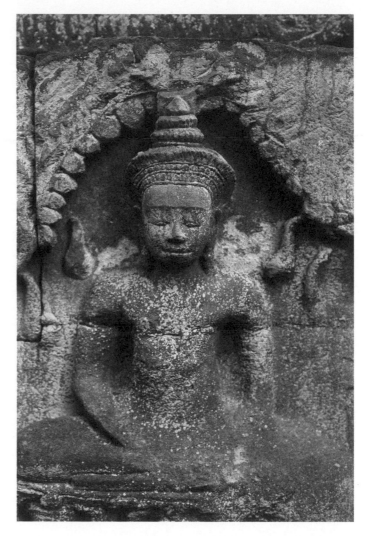

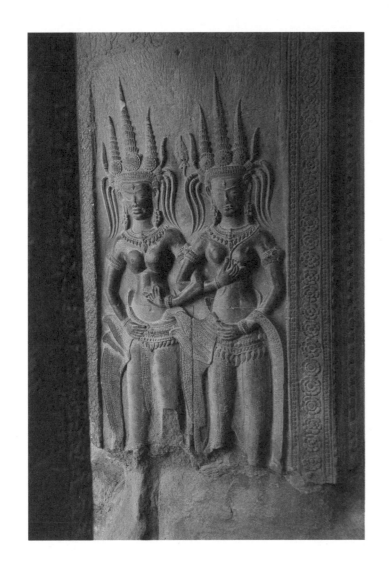

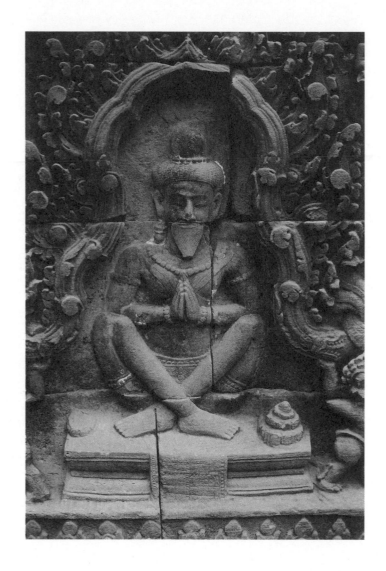

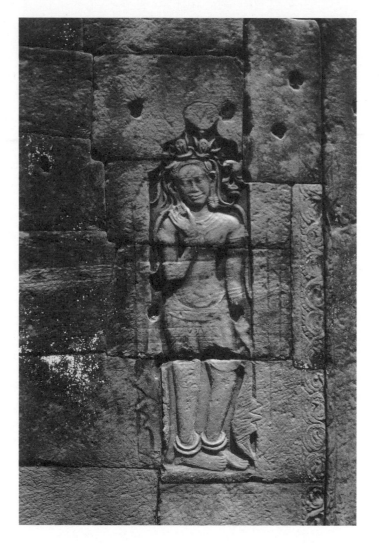

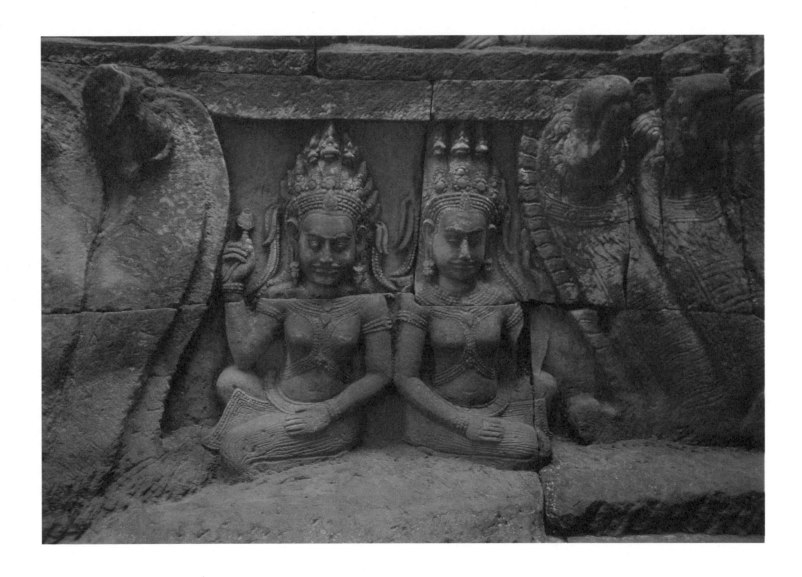

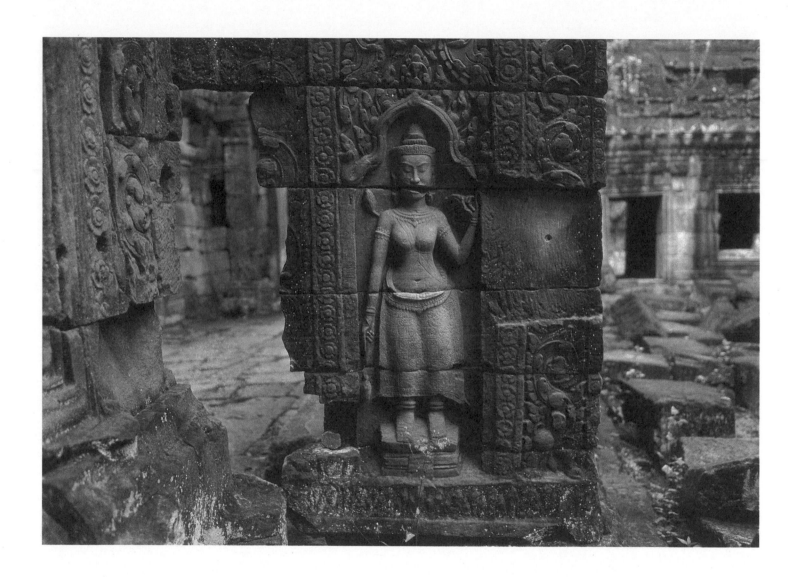

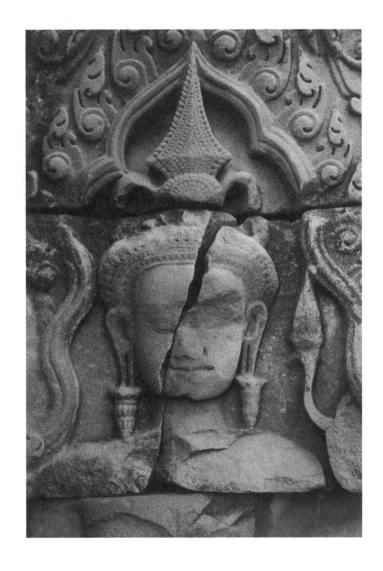

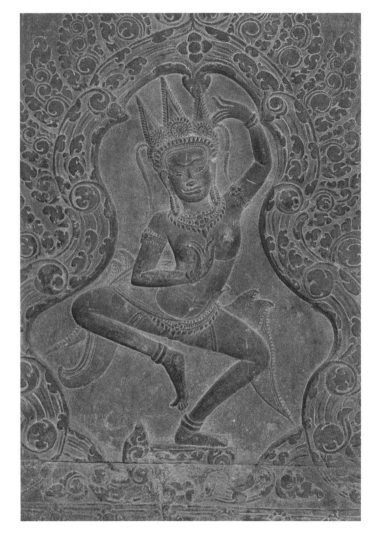

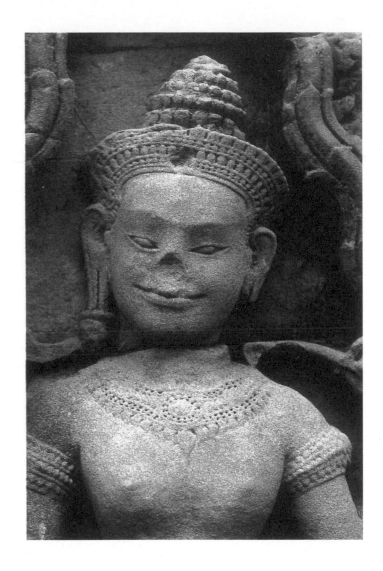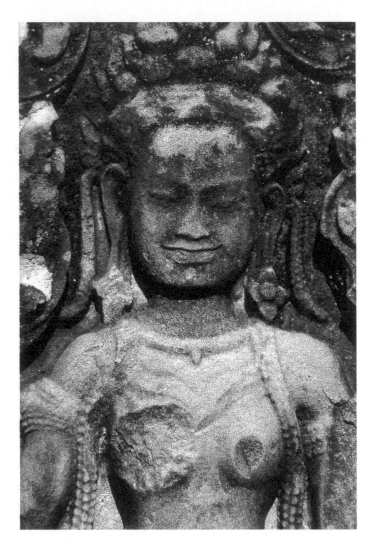

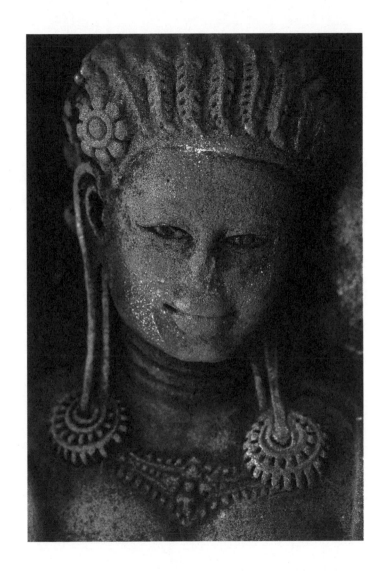

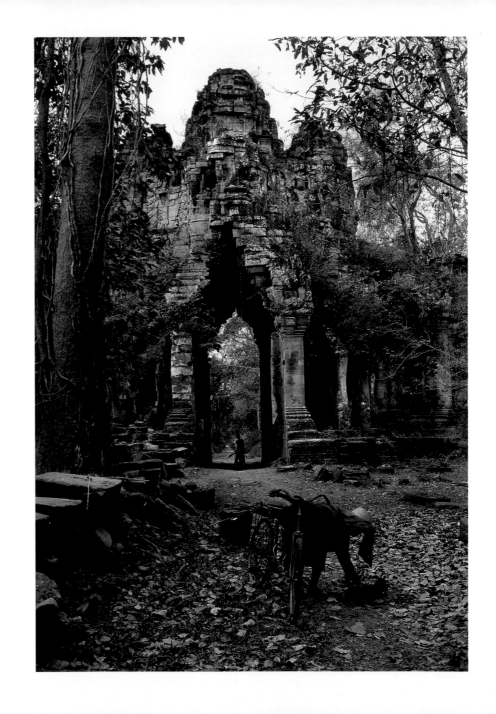

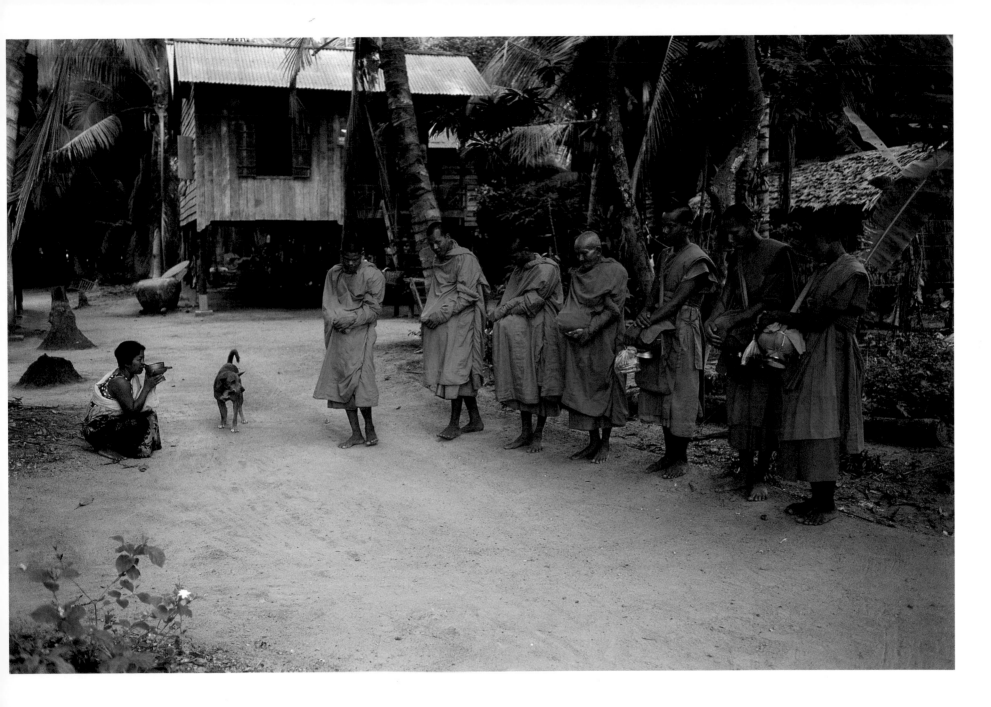

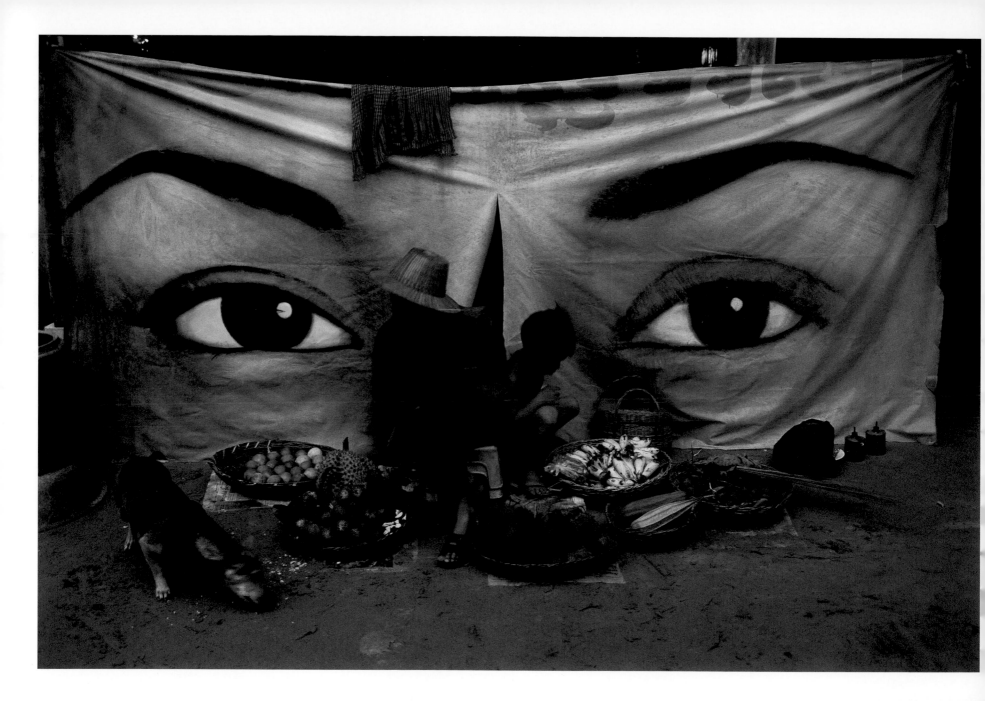

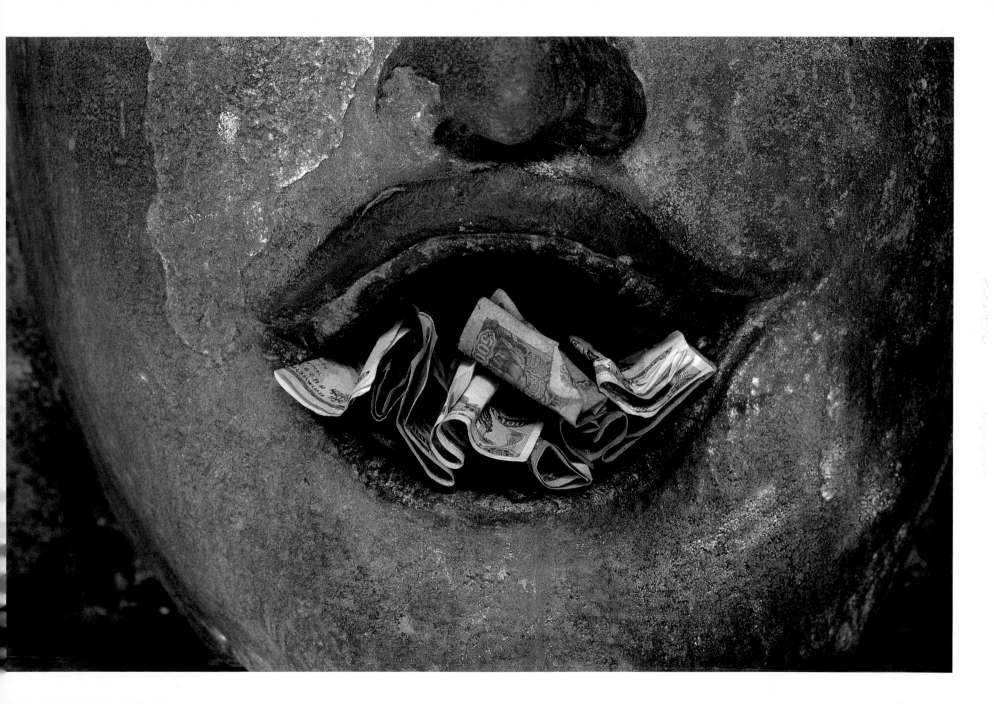

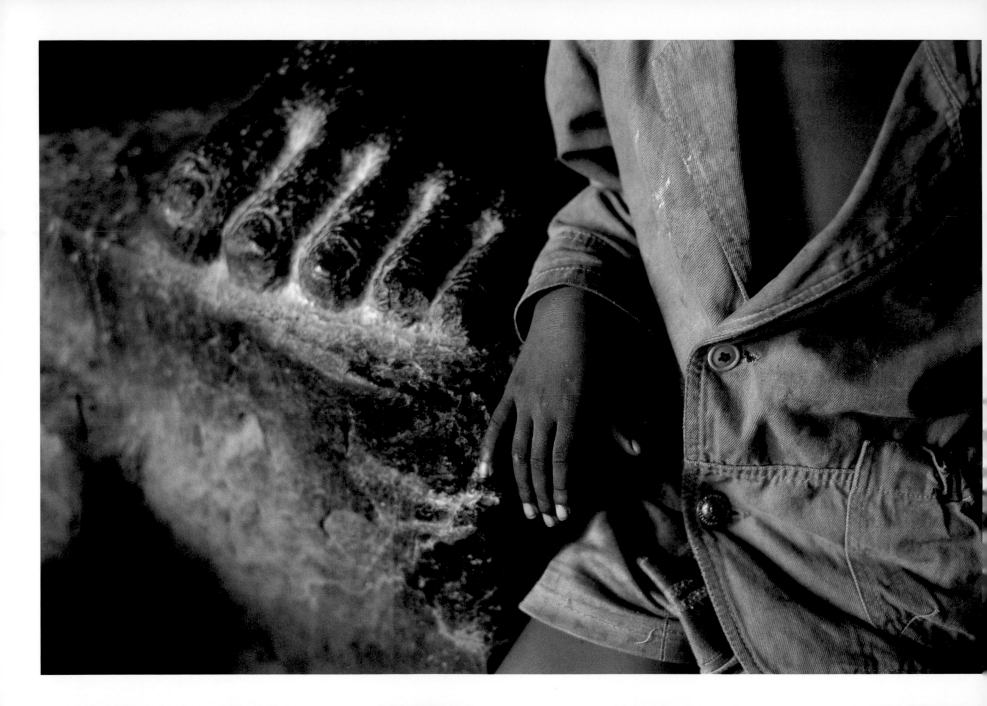

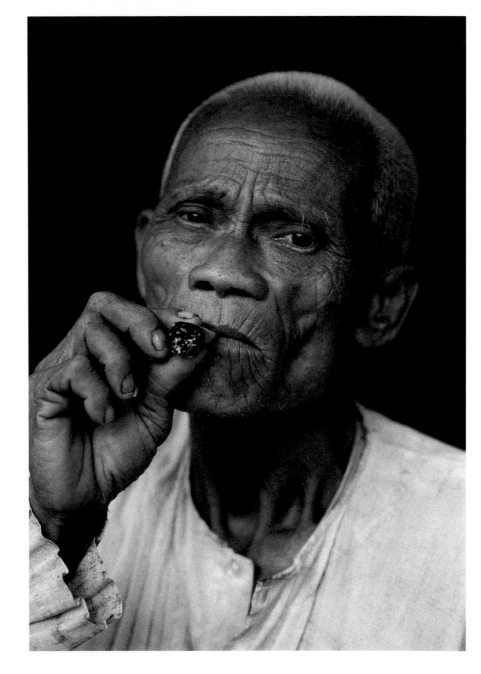

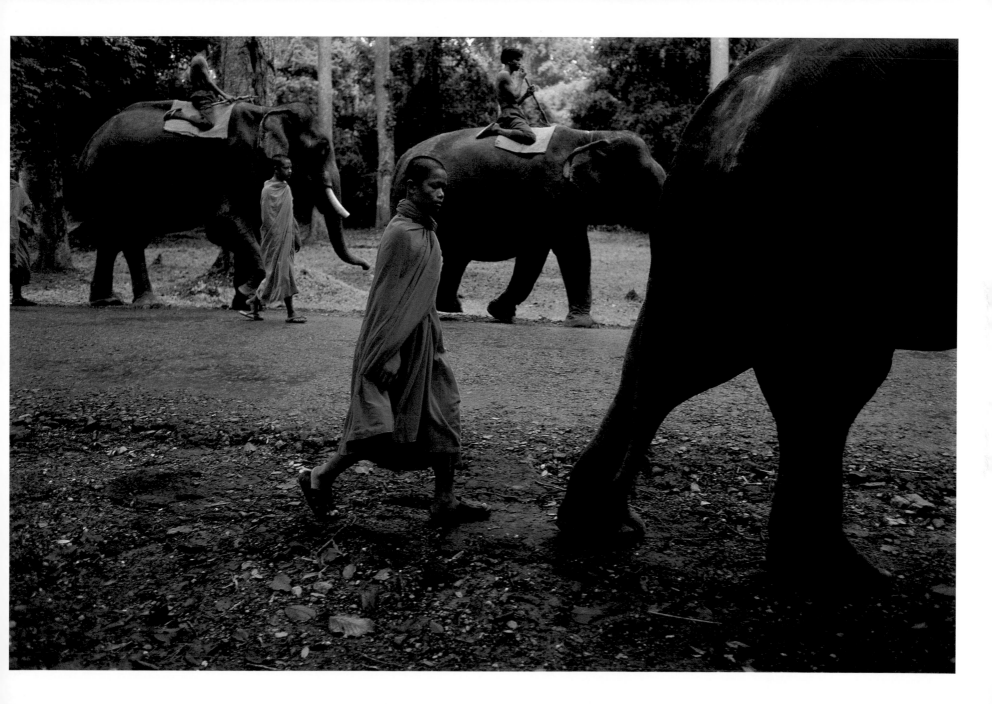

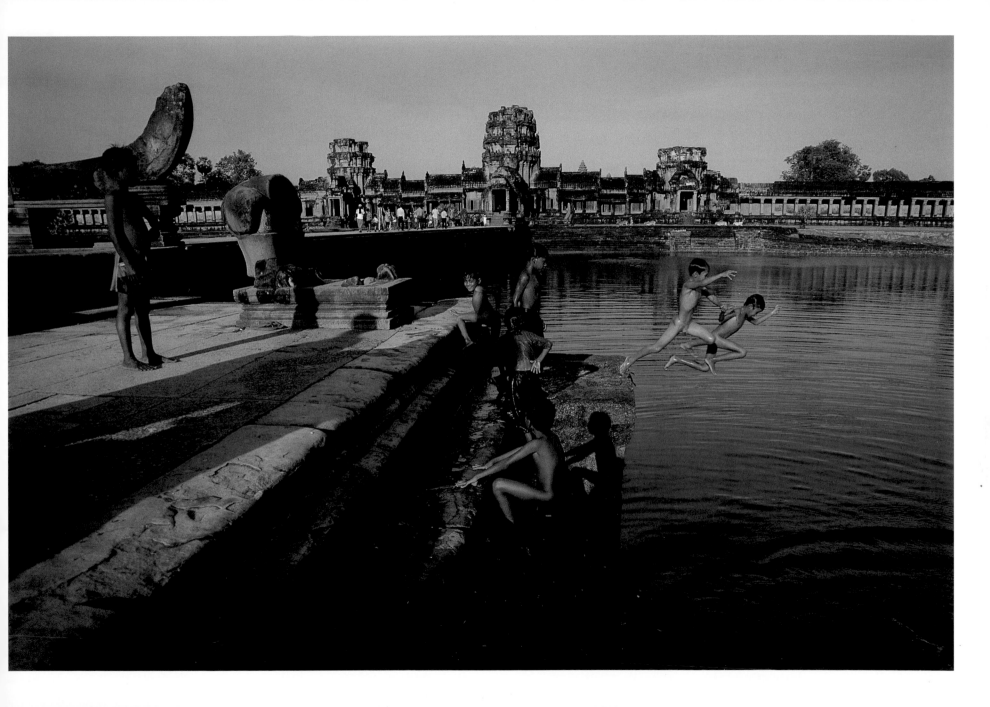

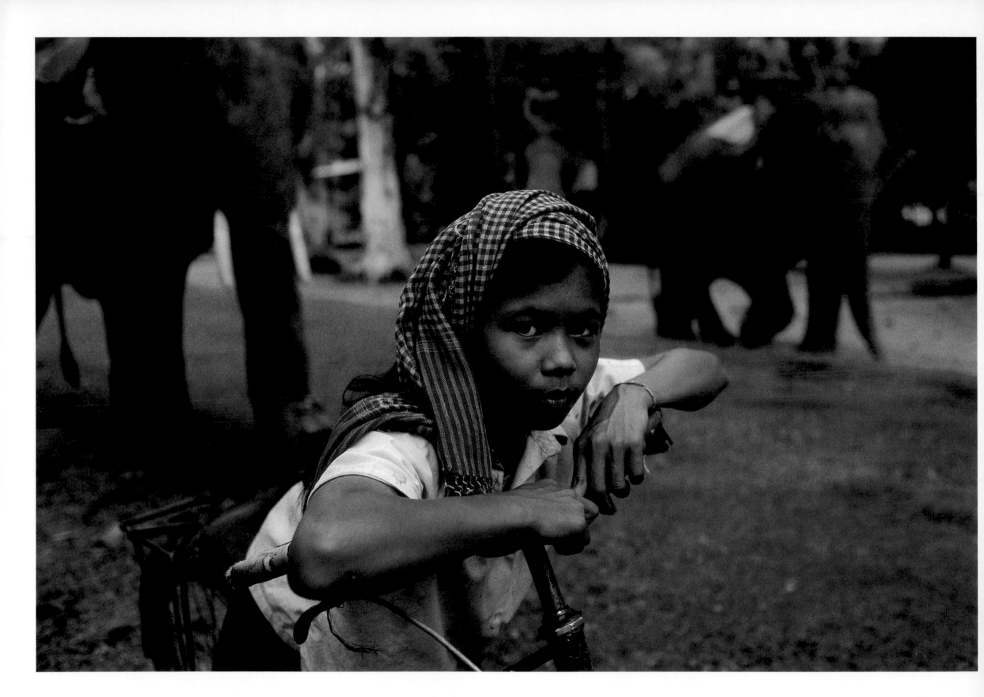

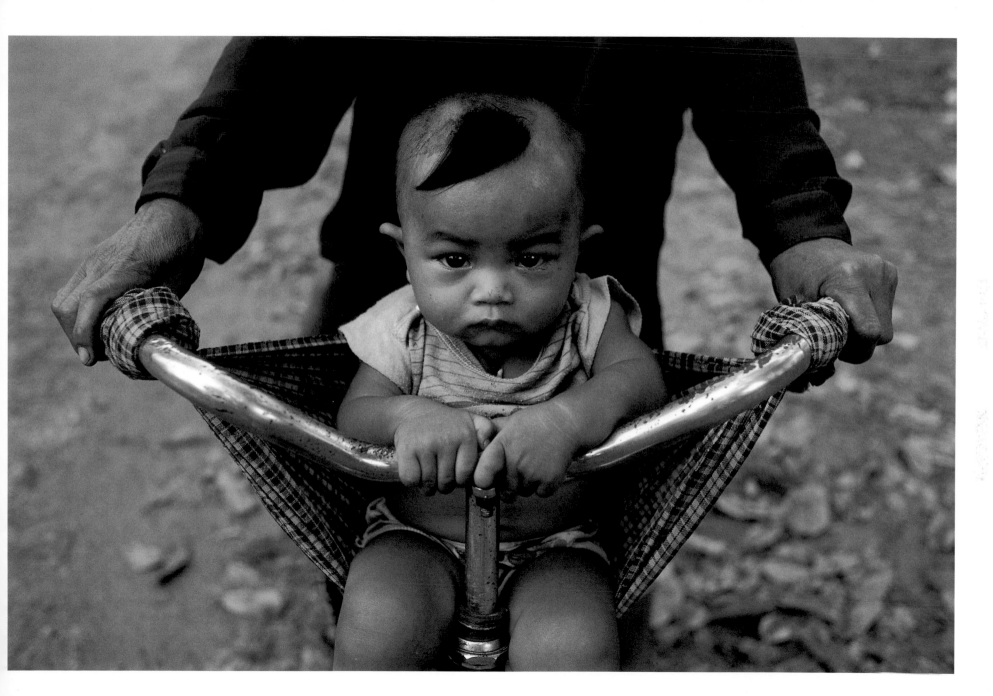

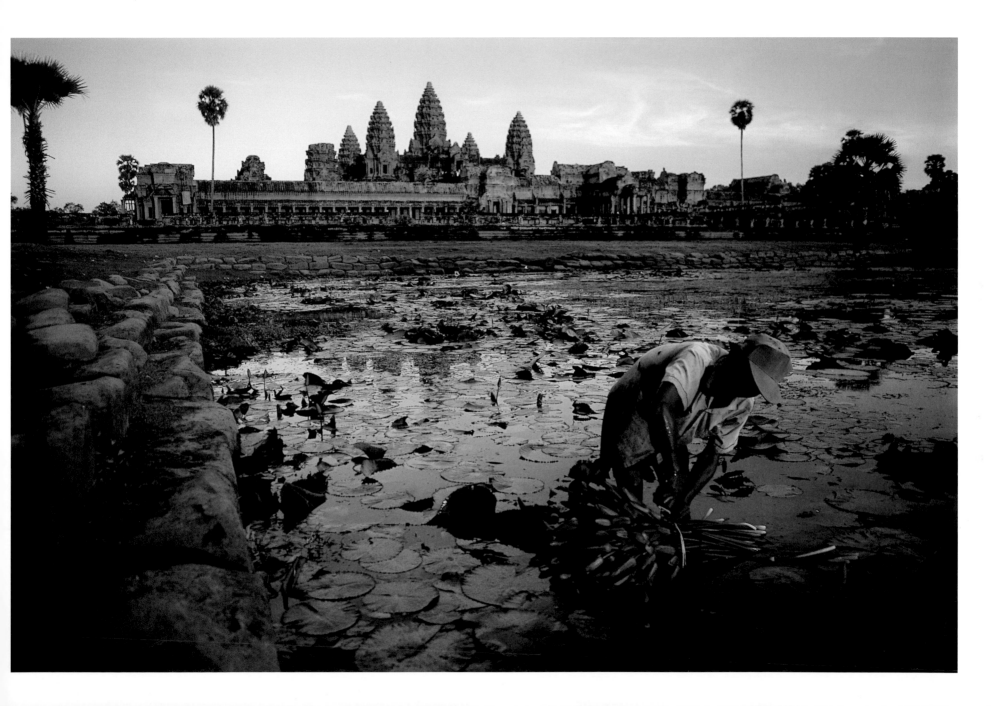

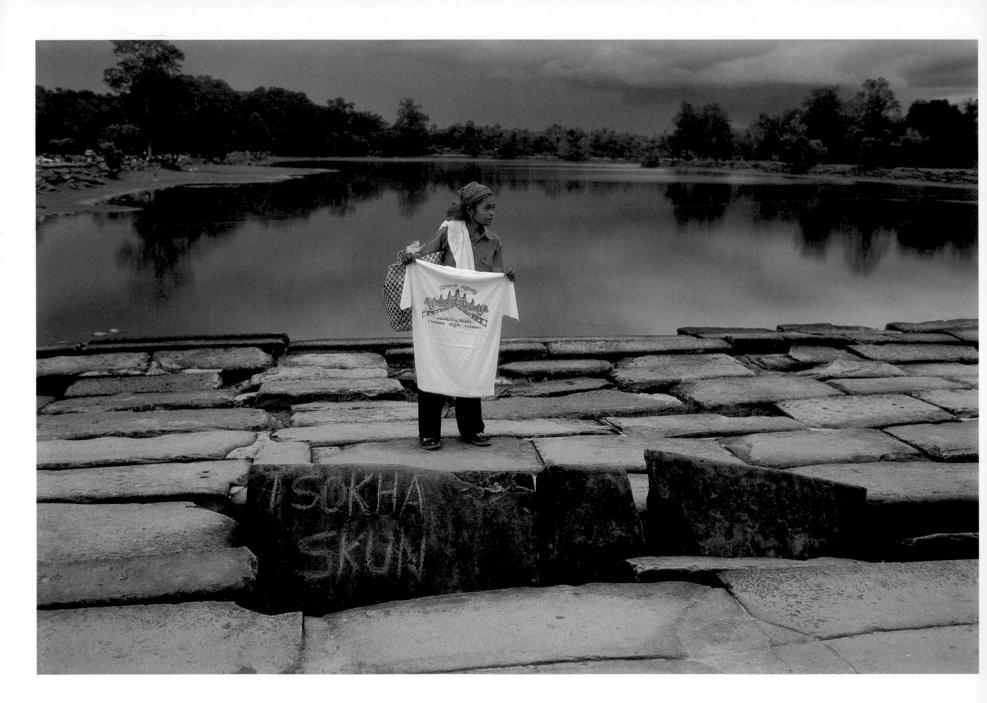

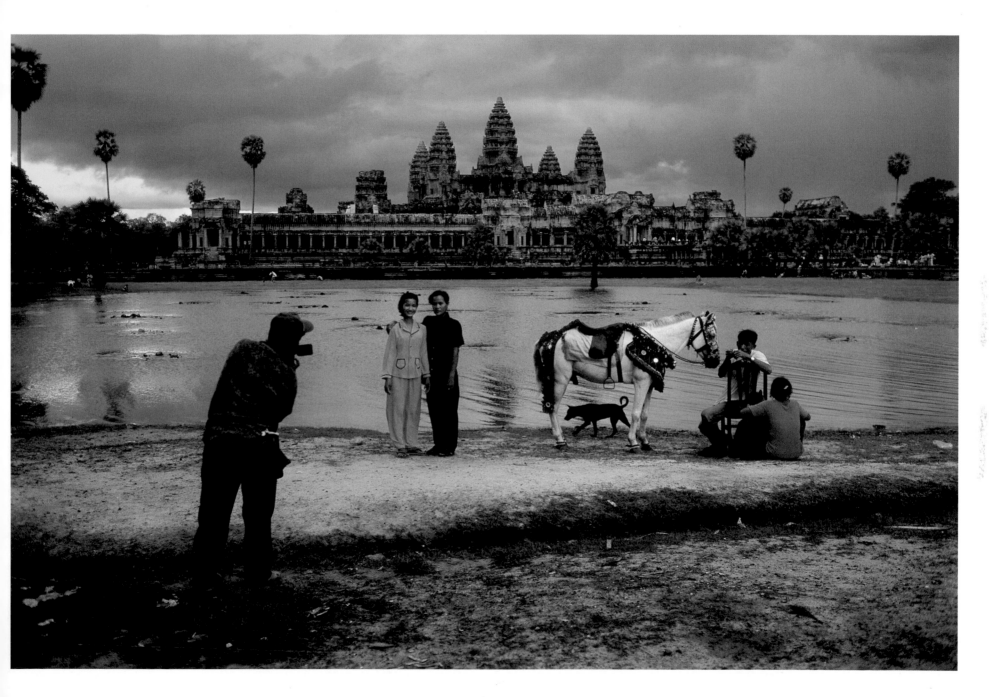

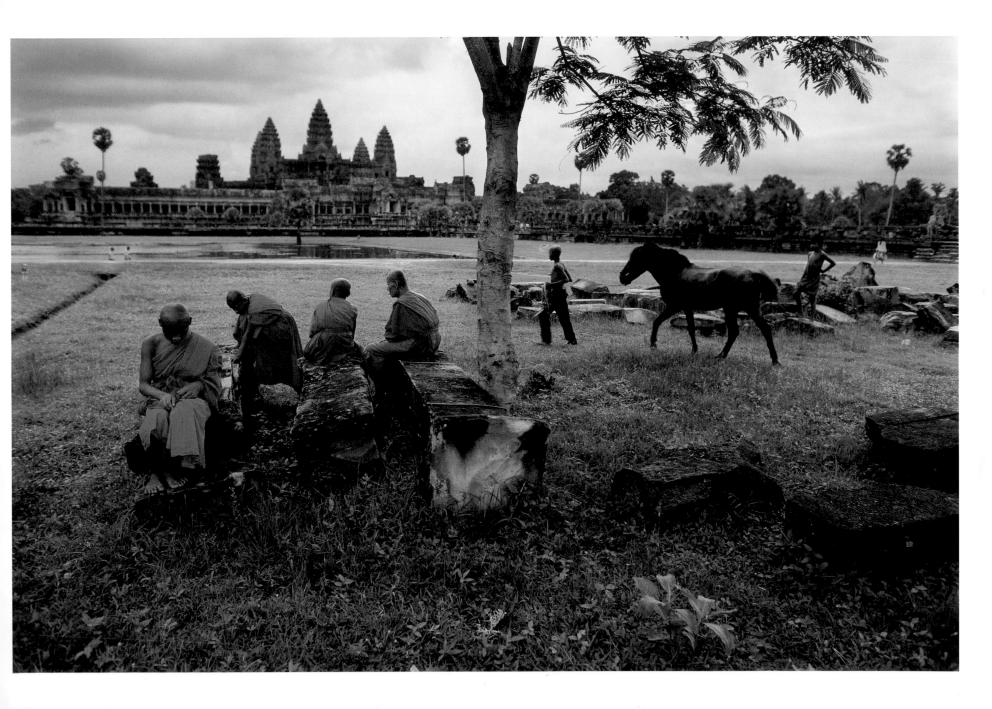

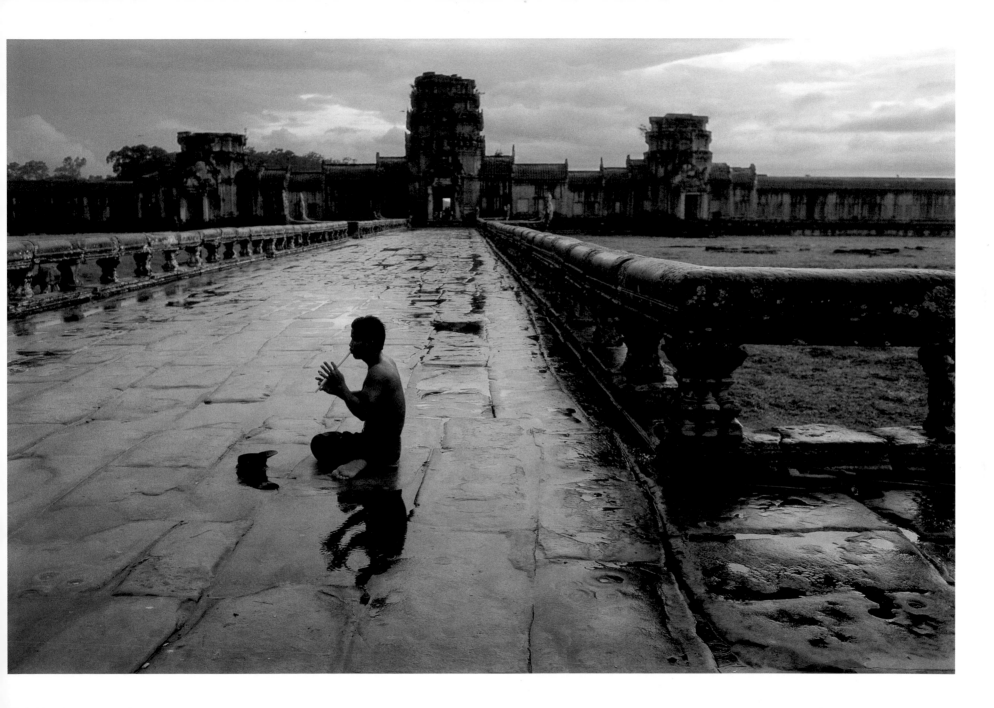

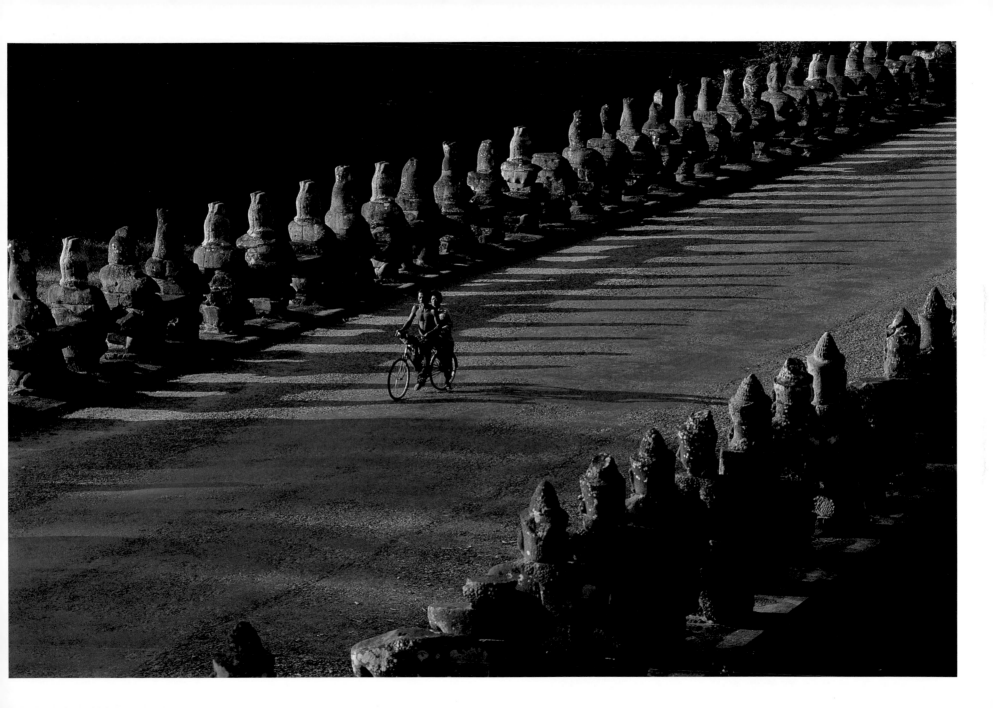

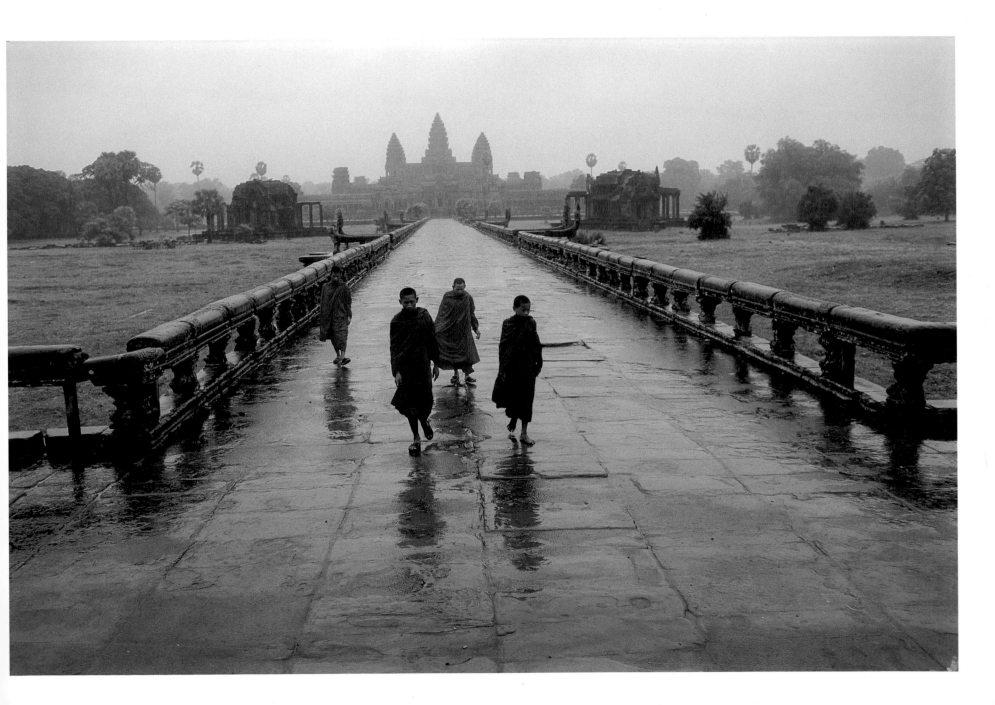

NORTH ↑

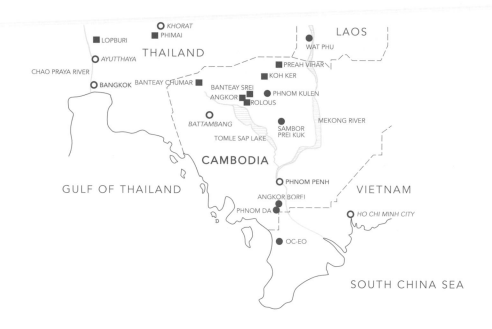

LAOS

KHORAT
PHIMAI
THAILAND
WAT PHU
LOPBURI
AYUTTHAYA
PREAH VIHAR
CHAO PRAYA RIVER
KOH KER
BANKOK
BANTEAY CHUMAR
BANTEAY SREI
PHNOM KULEN
ANGKOR
ROLOUS
MEKONG RIVER
BATTAMBANG
SAMBOR
PREI KUK
TOMLE SAP LAKE
CAMBODIA

GULF OF THAILAND
PHNOM PENH
VIETNAM
ANGKOR BORFI
PHNOM DA
HO CHI MINH CITY
OC-EO

SOUTH CHINA SEA

HISTORICAL CAMBODIA

● PRE-ANGKORIAN SITE
■ ANGKORIAN SITE
○ MODERN CITY
-- MODERN POLITICAL BORDER

MAPS NOT TO SCALE

NORTH ↑

BANTEAY SREI ↗

BARAY OF PREAH KHAN
(JAYATATAKA)

PREAH KHAN ■

■ NEAK PEAN

ANGKOR THOM

EAST BARAY

WEST BARAY

PALACE AREA

BAPUON
■
BAYON

■ EAST MEBON

■ WEST MEBON

■ TA PROHM

■ PRE RUP

SRAH SRANG

THE ANGKOR REGION

■ PHNOM BAKHENG

■ PRASAT AK YUM

■ PRASAT KRAVAN

STUNG SIEM REAP RIVER

■
ANGKOR WAT

■ TEMPLE
WATER

BARAY OF HARIHARALAYA

■ LOLEI

ROLOUS

■ PREAH KO

■ BAKONG

CAPTIONS

PAGE 15 BUDDHIST MONKS AT THE BAYON 16 A BOY AND HIS BROTHER AT PREAH KHAN 17 A PILGRIM AT THE BAYON 18 BUDDHIST MONKS AT THE BAYON 19 A BUDDHIST MONK AT TA PROHM 20 A BUDDHIST MONK WITHIN THE ENCLOSURE WALL AT ANGKOR WAT 21 BUDDHIST MONKS WALKING IN FRONT OF THE BAYON 23 BUDDHIST MONKS AT THE BAYON 25 BUDDHIST NUNS AT PREAH KHAN 27 STONE SCULPTURE AT THE BAYON 28 STONE SCULPTURE AT THE BAYON 30 STONE SCULPTURE AT THE BAYON 31(L) STONE SCULPTURE AT THE BAYON 31(R) STONE SCULPTURE AT THE BAYON 32 STONE SCULPTURE AT THE BAYON 33(L) STONE SCULPTURE AT THE BAYON 33(R) STONE SCULPTURE AT TA PROHM 34(L) STONE SCULPTURE AT TA PROHM 34(R) STONE SCULPTURE AT THE EAST GATE OF ANGKOR WAT 35(L) STONE SCULPTURE AT LEPER KING TERRACE, PALACE AREA, ANGKOR THOM 35(R) STONE SCULPTURE AT TA PROHM 36(L) PAINTED LIPS ON A STONE SCULPTURE AT LEPER KING TERRACE, PALACE AREA, ANGKOR THOM 36(R) STONE SCULPTURE AT LEPER KING TERRACE, PALACE AREA, ANGKOR THOM 37(L) STONE SCULPTURE AT BANTEAY KDEI 37(R) STONE SCULPTURE AT TA PROHM 38(L) STONE SCULPTURE AT TA PROHM 38(R) STONE SCULPTURE AT LEPER KING TERRACE, PALACE AREA, ANGKOR THOM 39 STONE SCULPTURE AT LEPER KING TERRACE, PALACE AREA, ANGKOR THOM 41 BUDDHIST MONKS AT TA PROHM 42 STONE SCULPTURE AT TA PROHM 43 BUDDHIST NOVICES AT THE BAYON 45 A CARETAKER AT TA PROHM 47 A BUDDHIST MONK AT THE MONASTERY AT ANGKOR WAT 48 A WOMAN IN PRAYER AT THE MONASTERY AT ANGKOR WAT 49 A BUDDHIST MONK AT THE MONASTERY NEAR LEPER KING TERRACE, PALACE AREA, ANGKOR THOM 51 TWO BUDDHIST NOVICES STUDYING SCRIPTURES AT THE MONASTERY AT ANGKOR WAT 52 BUDDHIST MONKS FROM THE MONASTERY AT ANGKOR WAT 53 THE MONASTERY AT ROLOUS 55 A BUDDHIST MONK AT THE MONASTERY AT ANGKOR WAT 56 A BUDDHIST MONK AT THE MONASTERY AT ANGKOR WAT 57 A BUDDHIST MONK SHAVES THE HEAD OF ANOTHER AT THE MONASTERY AT ANGKOR WAT 59 A YOUNG GIRL HAS WATER CEREMONIALLY POURED ON HER HEAD AT THE MONASTERY AT ANGKOR WAT 61 A YOUTH THE DAY BEFORE HIS INITIATION AS A BUDDHIST NOVICE 62 A BUDDHIST NOVICE AT THE MONASTARY AT ANGKOR WAT 63 A GIRL IN FRONT OF THE POOL AT ANGKOR WAT 65 A BUDDHIST MONK WITH HIS BICYCLE AT THE MONASTERY AT ANGKOR WAT 66 AN OLD MAN SLEEPING AT ANGKOR WAT 67 THREE BRIDESMAIDS WALK PAST A SLEEPING WOMAN AT THE ENTRANCE TO ANGKOR WAT 68 PREAH KHAN 69 A LITTLE GIRL AT ANGKOR WAT 71 TWO BUDDHIST MONKS ON THE CAUSEWAY AT ANGKOR WAT 73 A BLIND MUSICIAN AT THE TEMPLE OF ANGKOR WAT 75 TWO BUDDHIST NUNS AT THE LEPER KING TERRACE, PALACE AREA, ANGKOR THOM 77 A YOUNG DANCER APPLIES MAKE-UP BEFORE HER PERFORMANCE IN THE 'HALL OF DANCERS' AT PREAH KHAN 79 DEVOTEES BURN INCENSE AND SAY PRAYERS INSIDE A SMALL TEMPLE AT THE BAYON 80 A YOUNG BUDDHIST MONK AT ANGKOR WAT 82 STONE SCULPTURE WITH PAINTED LIPS AT TA PROHM 83(L) STONE SCULPTURE AT THE BAYON 83(R) STONE SCULPTURE AT ANGKOR WAT 84(L) STONE SCULPTURE AT ANGKOR WAT 84(R) STONE SCULPTURE AT TA PROHM 85(L) STONE SCULPTURE AT ANGKOR WAT 85(R) STONE SCULPTURE AT ANGKOR WAT 86(L) STONE SCULPTURE AT PREAH KHAN 86(R) STONE SCULPTURE AT ANGKOR WAT 87 STONE SCULPTURE AT LEPER KING TERRACE, PALACE AREA, ANGKOR THOM 88 STONE SCULPTURE AT PREAH KHAN 89(L) STONE SCULPTURE AT BANTEAY SREI 89(R) STONE SCULPTURE AT THE BAYON 90(L) STONE SCULPTURE AT TA PROHM 90(R) STONE SCULPTURE AT TA PROHM 91 STONE SCULPTURE AT BANTEAY SREI 93 A WOMAN AND HER BICYCLE AT THE EAST GATE OF THE BAYON 95 BUDDHIST MONKS COLLECTING FOOD FROM THE LOCAL COMMUNITY AT SIEM REAP 96 A FRUIT VENDOR IN FRONT OF A MOVIE POSTER AT SIEM REAP 97 OFFERINGS, NEAK PEAN 98 THE FOOT OF A STATUE AT ANGKOR WAT 99 AN OLD MAN AT PREAH KHAN 101 BUDDHIST MONKS AT ANGKOR THOM 103 CHILDREN SWIMMING, WESTERN CAUSEWAY, ANGKOR WAT 104 A GIRL ON A BICYCLE AT ANGKOR THOM 105 A BOY ON A BICYCLE AT BANTEAY SREI 107 A MAN HARVESTS LOTUS FLOWERS IN THE POOL AT ANGKOR WAT 108 A VENDOR SELLING T-SHIRTS AT THE ENTRANCE TO ANGKOR WAT 109 CAMBODIAN TOURISTS HAVING THEIR PICTURES TAKEN BY A LOCAL PHOTOGRAPHER IN FRONT OF ANGKOR WAT 111 BUDDHIST MONKS IN THE GROUNDS OF ANGKOR WAT 113 A BLIND MUSICIAN PLAYING HIS FLUTE ON THE CAUSEWAY LEADING TO ANGKOR WAT 115 THE SOUTH CAUSEWAY OF ANGKOR THOM 117 BUDDHIST MONKS AT ANGKOR WAT

ACKNOWLEDGEMENTS

The photographer would like to thank Bill Allen, Neil Baber, Chris Boot, Clay Burneston, Bob Dannin, John Echave, Neal Edwards, Stephen Goldman, Deborah Hardt, Gary Hayes, Frances Johnson, Audrey Jonckheer, Kent Kobertsteen, Ernie Lofblad, Deepak Puri, Amanda Renshaw, Richard Schlagman, Susan Smith, John Sanday, Pamela Singh, Paul Theroux, Bonnie V'Soske

Phaidon Press Limited
Regent's Wharf
All Saints Street
London N1 9PA

Phaidon Press Inc.
180 Varick Street
New York, NY 10014

www.phaidon.com

First published 2002
Reprinted in paperback 2005
© 2002 Phaidon Press Limited
Photographs © Steve McCurry

ISBN 0 7148 4559 0

A CIP catalogue record for this book is available from the British Library.

Designed by Melanie Mues
Printed in China